IMAGES
of America

THE NATIONAL ROAD
IN PENNSYLVANIA

Cassandra Vivian

ARCADIA

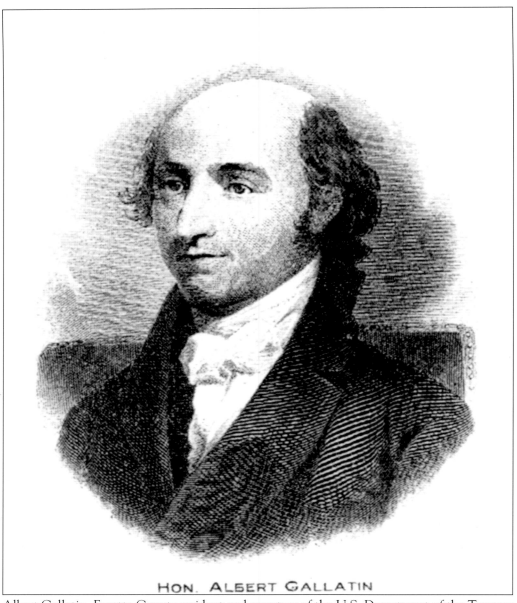

HON. ALBERT GALLATIN

Albert Gallatin, Fayette County resident and secretary of the U.S. Department of the Treasury under Thomas Jefferson, was the major champion of the National Road.

IMAGES
of America

THE NATIONAL ROAD
IN PENNSYLVANIA

Cassandra Vivian

ARCADIA

Published by Arcadia Publishing
Charleston SC, Chicago IL, Portsmouth NH, San Francisco CA

Printed in the United States of America

Library of Congress Catalog Card Number: 2002116262

For all general information contact Arcadia Publishing at:
Telephone 843-853-2070
Fax 843-853-0044
E-mail sales@arcadiapublishing.com
For customer service and orders:
Toll-Free 1-888-313-2665

Visit us on the Internet at http://www.arcadiapublishing.com

To my mother, Elizabeth Parigi Vivian.

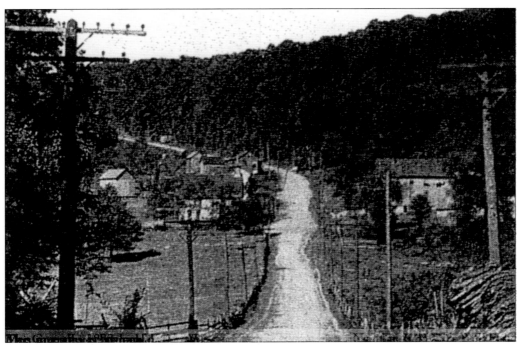

This view shows the National Road crossing from Maryland (foreground) into Pennsylvania (just before the buildings). (Bruce.)

CONTENTS

ACKNOWLEDGMENTS

I wish to extend thanks to the following (listed with abbreviations used for photographic credits throughout the book) for assistance or photographs: Tammy Haney, Mayor Norma J. Ryan, Sandra Mansmann (Mansmann), Donna and Bill of Old Pike Antiques (Old Pike), Vince Evans (Evans-Parcell), Pap's Place (Pap's), the Pittsburgh Post-Gazette (O'Neill-PG), Richard R. Moon of Moon Photos (Moon), and Jean Roberts (Roberts).

Thanks also go to those institutions that have given photographs from their archives: the Pennsylvania Room Collection, Uniontown Public Library (Uniontown); the Washington County Historical Society (Washington); the National Park Service, Fort Necessity National Battlefield (NPS) and the Earle R. Forrest Collection (Forrest-NPS); the Rutherford B. Hayes Presidential Library in Fremont, Ohio (RBHL) and the U.S. Department of Transportation Federal Highway Administration (RBHL-FHA-Rakeman); the National Road Heritage Corridor (NRHC); and the Brownsville Historical Society (BHS).

Additional thanks go to readers: Donna Holdorf, Mary Jane McFadden, and Carney Rigg. All remaining errors are mine. The National Road map on pages 20 and 21 is by Mark Yarris (Yarris).

It must be noted that there were many who wrote about, drew, photographed, and mapped the various roads that made up the National Road in Pennsylvania. They are the base upon which all future writers must build.

Thomas Searight (Searight) wrote his opus to the road in the 1890s. James Bruce (Bruce) followed soon after. John Lacock (Lacock, Lacock-NPS, and Lacock-Washington) walked Braddock's Road in 1910. Out of his efforts came an extensive written record and a series of exquisite photographs executed by Ernest K. Weller of Washington, Pennsylvania. Earle Forrest repeated Searight's feat with more emphasis on Washington County. Carl Rakeman (RBHL-BPR-Rakeman) worked for the Federal Highway Administration and created a series of paintings about roadwork in America, a number of them about the National Road in Pennsylvania. Malcolm Parcell, a Washington, Pennsylvania painter with an international status, gave the National Road international status in his art. Ray Forquer, also from Washington, painted a number of images of the road.

INTRODUCTION

The story of the National Road in the United States truly begins long before the first surface was created. It was probably the American Indians who originally found the routes over the Allegheny Mountains. They unquestionably followed the old animal trails that crisscrossed western Pennsylvania along the mountain ridges and valleys, and surely added routes of their own. Those paths were destined to become major highways in modern southwestern Pennsylvania. Route 30, leading west over the Allegheny Mountains via Fort Bedford and Fort Ligonier, was the Raystown Indian Path before it became Forbes Road. The Catawba Path, one of the great warrior paths of American Indians, bisected Pennsylvania north to south and became the approximate path of Route 119.

The National Road generally followed a number of paths. The most important was the Nemacolin Path, which crisscrossed often as it came up from Cumberland, passed modern Addison, and went on to modern Brownsville. The second was the Mingo Path, which picked up the route at the Monongahela River and crossed the plains to modern Washington on its way out of Pennsylvania. When Gen. Edward Braddock built his road, he moved in the same general direction as the Nemacolin Path but did not follow it precisely. Then Braddock veered north at the top of Chestnut Ridge and continued to the forks of the Ohio River in the general direction of the Catawba and Glades Paths. James Burd completed Nemacolin's route from the mountains to Brownsville. None of our modern roads follow the old paths exactly. Route 40, as we shall see, does not follow the National Road, since more modern technology allowed it to straighten out many of the switchbacks needed in earlier days.

By 1774, some 50,000 pioneers had crossed the mountains in what some scholars call the "first English-speaking trans-Appalachian frontier." The densest population of the settlers was in Fayette County just west of Chestnut Ridge (Chestnut Ridge, Chestnut Hill, Laurel Hill, and Laurel Ridge are all the same place, and the next ridge east is also called Laurel Hill); most were Marylanders or Virginians coming over Braddock's Road. Often, the men came alone. Once they had found a parcel of land, put in the first crop, and built a cabin, they trekked back over the trail to gather their families. Often they came with nothing—just a few items they could hand carry or pack on a mule. They walked, and so did their children. By 1780, the government gave land west of the Alleghenies to Revolutionary War soldiers as payment for services, just as they had done after the French and Indian War. It was a formidable human movement—unsurpassed except for the great European immigration that was to follow over a century later.

In 1784, George Washington, concerned over the loyalty of the western country, proposed a proper road west "to open wide the door and make a smooth way for the Produce of that Country to pass to our Markets." His comments were prophetic, for lack of good roads helped spawn the Whiskey Rebellion in 1791. The national government had to become involved in the road-building business. Congress took up the issue. Good roads were a major problem for fledgling America. Even before the ink was dry on the documents, legislators were struggling with the problem of transportation, not only in the halls of Congress but on the mud-filled paths leading them to the capital. In fact, in 1789, the first Congress did not have a quorum because the the newly elected legislators were still trying to get to the capital. Still, their reluctance to have the national government take on such a responsibility is evidenced by the fact that it was not until 1806 that creating a road from Cumberland to Ohio was authorized by Congress. As late as 1822, when portions of the road were already being used, debate continued as to whether the national government was legally able to construct a roadway.

It was a struggle every inch of the way: first in the government offices, where the road had to be debated, approved, and funded, and then on the roadway itself, where it had to be pounded out of the mountains and forged into a passable road. The National Road was originally planned to start at Baltimore and end in St. Louis, linking the cities in the East with the ever expanding territories of the West. Every city and hamlet along the proposed route negotiated to have the road cut through its heart. A lot of politicking took place to determine its course.

It was a nightmare. The War of 1812 delayed progress. Costs mounted. From Cumberland to Wheeling, the road cost over $13,000 per mile. Maintaining the road was an additional expense. Wagons tore the surface apart, and vandalism was rampant. This was still a place of free spirits, not yet accepting of the concept of public property. People took the gravel for their own use and altered the right-of-way to erect houses and gardens where the road had originally stood.

By referencing local newspapers, Earle Forrest tells us that by 1818, the road had been completed to Brownsville and, in 1820, across Washington County and on to Wheeling. By 1834, the federal government wanted out of this costly venture and was determined to turn it over to the individual states. The states, however, refused to assume the financial burden of maintenance of such a roadway. Thus, it was determined that the federal government would repair and macadamize the road before relinquishing it to the states and that the individual states would impose a tax on travelers for future maintenance. That is when toll houses were erected.

Ultimately, the National Road was never completed. Instead of beginning in Baltimore in the East, it began in Cumberland; in the West, it ended at Vandalia, Illinois, well short of St. Louis. Why? The same reason that the waterways never reached their potential—progress. The road came before the waterways could be developed. Now the railroad was arriving before the roadway could be completed. By 1826, the Baltimore and Ohio Railroad was laying track in Fayette County. By 1853, both the Pennsylvania and the Baltimore and Ohio Railroads were open for business in western Pennsylvania. They were quicker, cheaper, and more comfortable. The railway became the dominant force in transportation in the eastern United States.

Despite its champions and the incredible adventures along its route, nothing could keep the road alive when the railway arrived. The National Road became obsolete. The freighters and drovers moved westward or were unemployed. The stagecoach lines went out of business. The taverns closed their doors. The pike towns languished. Even the federal government moved its business to the railroads. The last mail coach ran the National Road on December 31, 1852. The road went deafeningly silent—no more gallant wagoners fighting blizzards to get their loads through, no more stumping politicians on their way to Washington, and no hogs or sheep screaming to be fed in wagon yards. No johnnycakes or Baltimore oysters were served up around the tavern fireplaces, and there was no more minding one's p's and q's as the tavern keepers chalked up the wagoners' pints and quarts before shutting them off. Potholes, rust, and decay

set in. Only toll houses remained, levying tolls in diminishing numbers as more travelers and more turkeys, pigs, and geese got "off the hoof" and "rode the rails" to market. The toll houses did not shut their doors until April 10, 1905. The people, who had staked their fortune on the great roadway westward (like those before them, who had chosen the rivers as their piece of the American dream), fell victim to progress and the turn of events. They lamented in a ditty of the day:

> Now all ye jolly Waggoner, who have got good wives,
> Go home to your farms, and there spend your lives.
> When your corn is all cribbed and your small grain is good
> You'll have nothing to do but curse the railroad.

The automobile put America back on the road, and the tired, old National Road—badly in need of repair but fresh with mountain air, great woodlands, and historic sites to visit—received the automobile with open arms. The surface was smoothed, bridges were rebuilt, and the road entered a new phase of glory. The National Olde Trails Road Association, begun in 1913, promoted and took the responsibility of the road. America was ready for some fun. People came on bicycle and hup-mobile, in the Sears motor wagon, and in Henry Ford's Model T (he tested his automobile on the dangerous slopes of Chestnut Ridge), and they spent the night, or the week, in plush new resorts like Gorley's, the Summit Inn perched atop Chestnut Ridge, log cabin motels (forerunners of our modern-day campgrounds), and tourist homes.

After all these years, the dream of a roadway linking America had not died, and the federal government never did get out of the road-building business. In 1925, Route 40 finished what Congress started so many years ago. Stretching from Atlantic City on the eastern seaboard to San Francisco on the West Coast, it linked America, and in its heart sat the old National Road.

While meandering over quiet stretches of the National Road in Pennsylvania on a lazy afternoon, it is not hard for a true road aficionado to envision the road as it once was—to see Ann Hupp gallantly rallying the women at Miller's Blockhouse to reload their rifles as she fought off a brutal Seneca attack, or to see the angry men of the Whiskey Rebellion raising their flag in defiance of the new government. The images keep coming as one envisions Boss Rush at Farmington, entertaining Jenny Lind around the fire of his stagecoach tavern. One can see Lucius Stockton, owner of the stagecoach line, racing a steam engine with his famous horse to prove the road, not the railroad, was king in Pennsylvania. One can imagine Hunny Thompson, Josiah van Kirk Thompson's second wife, prancing around Uniontown with her tally-ho and trumpet, dressed to the nines and scandalizing the people of the countryside. No image, however, is stronger than that of old Thomas Searight, buried beside the road he loved so well. Searight's ghost owns this road more than any other person could. As he wrote in his book *The Old Pike*, he "saw it in the zenith of its glory, and with emotions of sadness witnessed its decline." He shouted out for the world to hear that the National Road "was a highway at once so grand and imposing, an artery so largely instrumental in promoting the early growth and development of our country's wonderful resources, so influential in strengthening the bonds of the American Union, and at the same time so replete with important events and interesting incidents." Thomas Searight understood the gift the road gave to America.

He would have been overjoyed to see the American Science Wizards Race with the likes of Einstein, Edison, Damiler, Burroughs, and Firestone, churning up the dust as they raced up and down the hills and through the valleys much as he enjoyed listing the luminaries of his day: "Jackson, Harrison, Clay, Sam Houston, Polk, Taylor, Crittender, Shelby, Allen, Scott, Butler, the eccentric Davy Crockett and many of their contemporaries in public service were familiar figures in the eyes of the dwellers by the roadside."

The National Road—alternately called the National Pike, the Cumberland Road, and a century later, Route 40 (erroneously)—was the first federally built road in the United States.

In Pennsylvania, it bounds over Negro Mountain and enters the state on its way to Addison. It crosses the Youghiogheny River, climbs Woodcock Hill, and makes its way down three-mile-long Chestnut Ridge to Uniontown. Continuing across the Monongahela River at Brownsville, it coasts through the new "pike towns" of Beallsville and Centerville before forging up Scenery Hill on its way to Glyde and Washington. After passing Claysville, it exits Pennsylvania at West Alexander.

The National Road was designated a National Historic Civil Engineering Landmark in 1976, a State Heritage Park in 1994, a State Scenic Byway in 1995, and a National Scenic Byway All-American Road in 2002. Along the 90 miles of road in Pennsylvania, there are seven historic districts, and 79 sites have been deemed eligible for listing on the National Register of Historic Places. Of those, 48 have already been declared. The National Road still runs through a rural landscape. Restaurants offer down-home cooking sometimes in the very taverns that were so popular in the road's heyday. Wonderful old farmhouses dot the countryside, and cultivated fields bask in the strong Pennsylvania sunshine. The National Road is sprucing up in yet another century. Its wonderful taverns and toll houses have been restored for a new group of tourists, with a new dream of welcoming America on its path. Thomas Searight was right; it is still the road of roads.

One

EARLY TRAILS
AND MILITARY ROADS

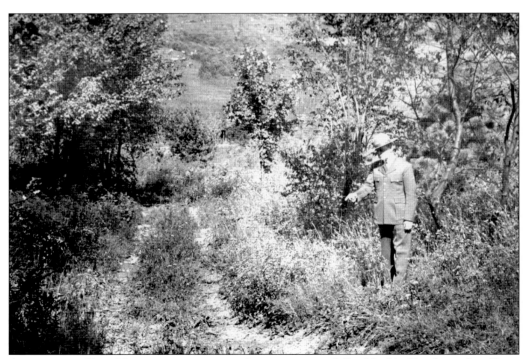

A ranger at Fort Necessity points out the remnants of Braddock's Road at the Great Meadows. (NPS.)

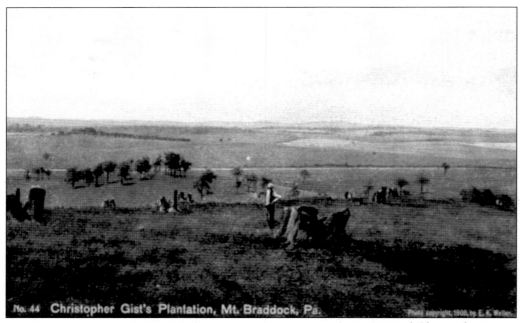

No. 44 Christopher Gist's Plantation, Mt. Braddock, Pa.

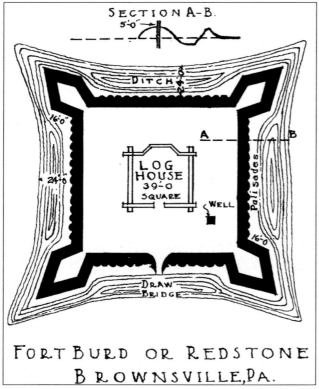

SECTION A-B.

5'-0'

DITCH

LOG HOUSE 39'-0 SQUARE

Palisades

WELL

16'-0'

16'-0'

24'-0

DRAW BRIDGE

FORT BURD OR REDSTONE BROWNSVILLE, PA.

A man named Christopher Gist opened the path west for the Ohio Company in 1751. A year later, he returned with Thomas Cresap and Nemacolin, a Delaware Indian, to blaze tomahawk markings on tree trunks from Wills Creek to the Youghiogheny at Great Crossing. Gist then founded his community, Mount Braddock (above). Other early settlers established forts. One of the first was Redstone Old Fort on the hillside over the Monongahela River. They found the coal had been burned to slag by some fire years earlier, so they called it Redstone Old Fort. After Thomas and Basil Brown bought it c. 1785, it became Brownsville (left). (Above, Lacock-NPS.)

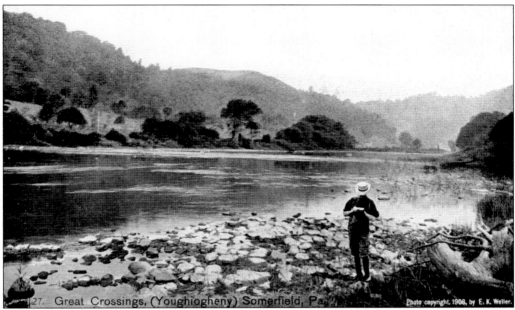

27. Great Crossings, (Youghiogheny) Somerfield, Pa. Photo copyright 1906, by E. K. Weller.

George Washington and Christopher Gist crossed the Youghiogheny at Great Crossing on November 18, 1753. Washington came again in 1754, this time to build a proper road. His men ran into trouble at Jumonville Glen, where 13 Frenchmen were killed, including de Jumonville. This was the first confrontation between the French and British that resulted in a death. Washington retreated to the Great Meadows (below) and hastily built Fort Necessity in the event of trouble. He continued his original mission of road building. On a rainy July 3, 1754, the attack came and Washington and his men, who had scurried back to the small fort, were defeated. It was an international incident, as it led to the French and Indian War. (Above, Lacock-NPS.)

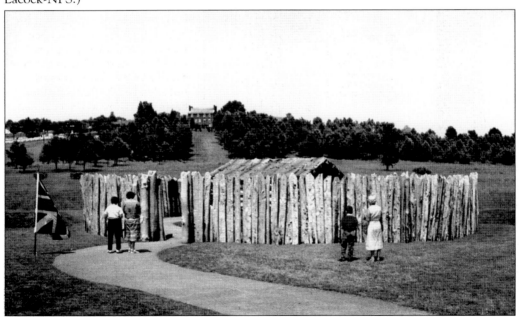

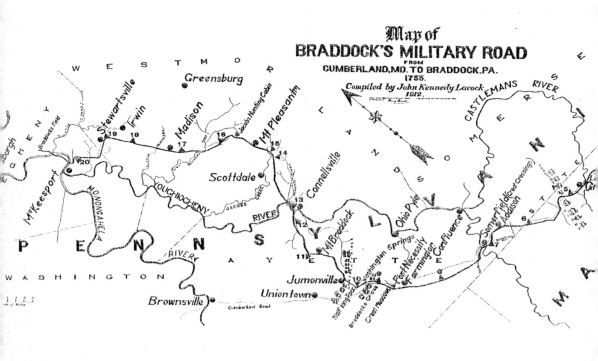

Map of
BRADDOCK'S MILITARY ROAD
FROM
CUMBERLAND, MD. TO BRADDOCK, PA.
1755.
Compiled by John Kennedy Lacock
1912.

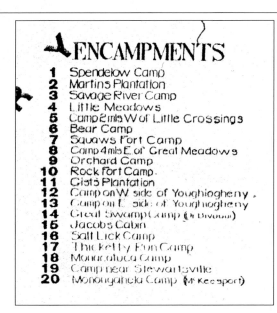

ENCAMPMENTS

1. Spendelow Camp
2. Martins Plantation
3. Savage River Camp
4. Little Meadows
5. Camp 2 mls W of Little Crossings
6. Bear Camp
7. Squaws Fort Camp
8. Camp 4 mls E of Great Meadows
9. Orchard Camp
10. Rock Fort Camp
11. Gists Plantation
12. Camp on W side of Youghiogheny
13. Camp on E side of Youghiogheny
14. Great Swamp Camp (or bivouac)
15. Jacobs Cabin
16. Salt Lick Camp
17. Thicketty Run Camp
18. Monacatuca Camp
19. Camp near Stewartsville
20. Monongahela Camp (McKeesport)

The first true wagon road west of the Allegheny Mountains was Braddock's Road. Braddock had to build a 12-foot-wide military road along the existing pathway to accommodate an army. It was a formidable assignment. In 1910, the John Lacock expedition documented the road. His efforts produced this map, linking Braddock's sites to modern towns and roads. (Lacock.)

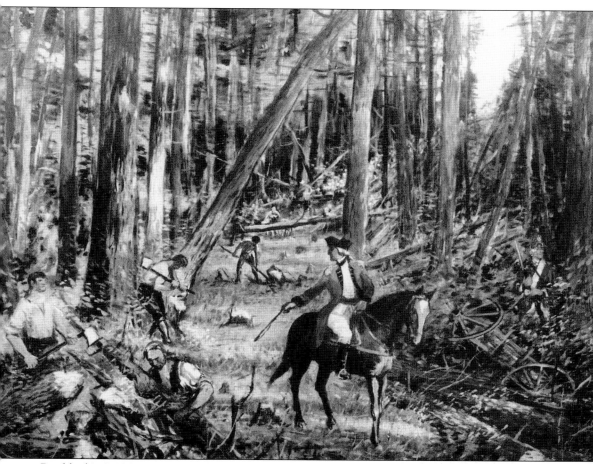

Braddock's 2,100 carpenters, sawyers, sailors, and soldiers struggled with 300 wagons (each weighing 1,400 pounds), 3,000 horses, 2,000 head of cattle, 200,000 pounds of flour, 10,000 sandbags, 400 spades, and 4 eight-inch howitzers (each behind a nine-horse team). They pushed, pulled, and hauled them up one mountain and down the other while they chopped down underbrush and trees and uprooted rocks to begin their road. (RBHL-BPR-Rakeman.)

After a grueling day of hacking out two to seven miles of wilderness, campsites had to be found, each with enough water for the army and its camp followers. Braddock set up his eighth camp on June 24, 1755, at a spot he called Twelve Springs. Today, it is about a half-mile south of the National Road near Glison's Restaurant and the old Shaw-Griffith Tavern. (Lacock-NPS.)

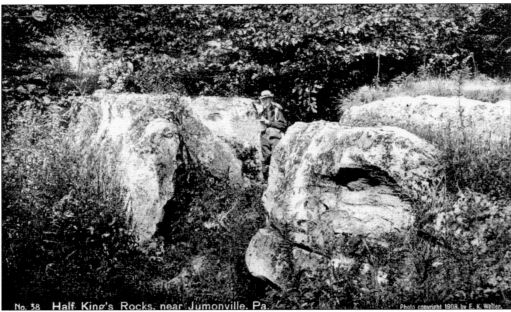

Still in the thick forests, Braddock and his army stopped on June 28, 1755, at Rock Fort Camp. The massive rock formations gave safety to the resting troops while the nearby spring, now called Washington Spring, guaranteed water. At this point, Braddock's Road rises out of the woods and turns north. The modern road joins it. Directly opposite the springs is Great Rock, or Half King's Rock. (Lacock-NPS.)

In June and July 1755, Col. Thomas Dunbar, one of Braddock's officers, destroyed his artillery and ammunition and burned $500,000 worth of stores and baggage here. From the fragments found in the area, three small brass cannons were created. One is in Pittsburgh, the second at the Orphan's School of the Jumonville Retreat and Conference Center. The third was at Fort Necessity until it was given to the war effort during World War II. (Lacock-NPS.)

At Laurel Ridge, Braddock's Road veers northwest away from the path of the future National Road. From atop Laurel Ridge, the National Road follows Burd's Road west to Brownsville. James Burd was commanded to finish what Washington and Braddock had begun. He followed the ill-fated Braddock expedition into the western country and the Nemacolin Path (somewhat) to the Monongahela at Redstone Old Fort, modern Brownsville.

17

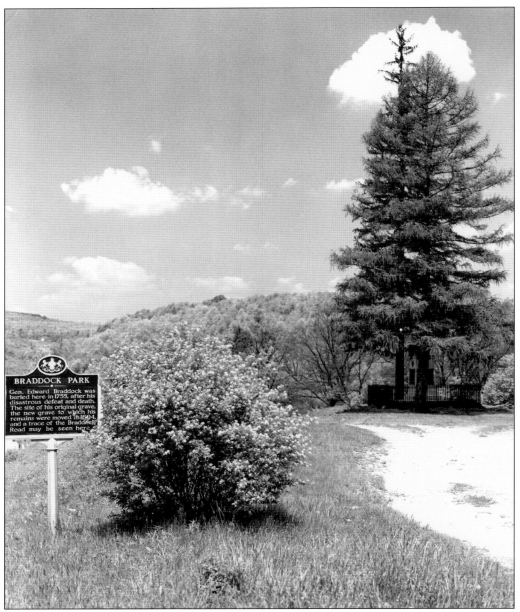

Braddock's Road stops on the far shores of the Monongahela, where his army was defeated by the French and American Indians. Braddock was mortally wounded probably by his own men. He died during the retreat along his newly forged road and was buried by Washington. In 1804, while crews were repairing Braddock's Road, the body was reburied nearby. In 1913, with the Coldstream Guards of the British army present, a granite monument was placed over his grave. (Lacock-NPS.)

Two

BUILDING AND RIDING
THE NATIONAL ROAD

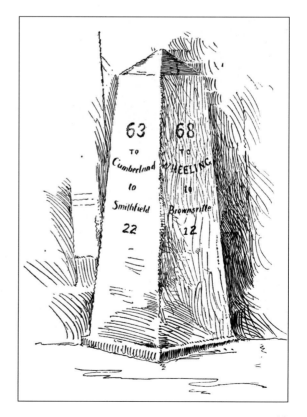

During the 1830s, cast-iron obelisk-shaped mileposts replaced the original stone tablets of 1816–1820. The 90 mileposts in Pennsylvania were embedded in concrete on the north side of the road, one per mile. A Connellsville foundry forged posts from Cumberland to Brownsville, and a Brownsville foundry continued from Brownsville to Wheeling. (Searight.)

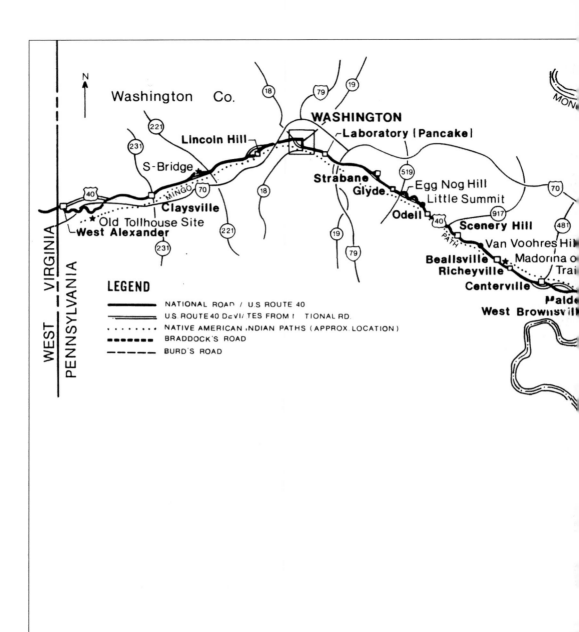

The National Road cuts the corner of Pennsylvania because the state insisted the road enter the state (Virginia objected) and pass through Uniontown and Washington. To acquire right-of-way from Pennsylvania (which the federal government needed) without losing the state in the next election, the federal government agreed to alter the route.

Braddock's Road varies considerably from the National Road, and scholars maintain it is not considered the same road at all. It enters Pennsylvania in approximately the same place, but the two roads seldom converge. Braddock's Road runs south of the National Road through to the Great Meadows, the largest known forest clearing of the area. Near Braddock's grave site,

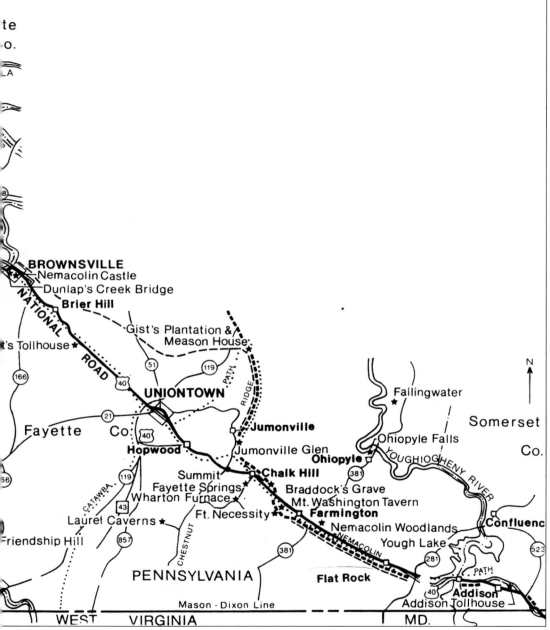

it crosses to the north of the National Road, climbs Chestnut Ridge, and continues northwest to the Monongahela River at what is now the town of Braddock.

The National Road and Route 40 are not the same road either. They do, however, move through the same areas and are often intertwined. Route 40 runs straight, for the most part; the National Road does not. The latter serpentines around the former most of the time. This map shows many of the instances when they are not the same, but not all the instances, as some are ever so slight. (Yarris.)

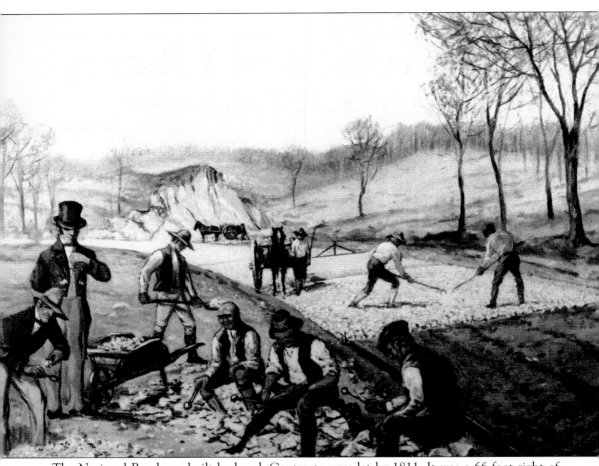

The National Road was built by hand. Contracts were let by 1811. It was a 66-foot right-of-way with a 32-foot roadbed and a 20-foot-wide stone path for traffic. The 12- to 18-inch-deep roadbed was filled with broken stone, deeper in the center and tapered at the ends. The stone had to pass through metal rings for size and was rolled to a level surface on the road. (RBHL-BPR-Rakeman.)

The Genius of Liberty

AND FAYETTE ADVERTISER

VOLUME ISSUE	UNION	Total No. 506

CUMBERLAND ROAD

The committee to whom was referred the Message of the President of the U.S. of America

UNDESCIFERABLE

They are of opinion that an appropriation for erecting a bridge over the Youghiohany river, would be improper at this time; because, by law, the superintendent in making the road has power to deviate from the original survey; only that the road shall pass through the principal points established. If then a bridge should be erected over said river, that place must necessarily become fixed as a point to which the road must lead ; and being many miles in advance of the parts of the road contracted for, might prove inconvenient in the future prosecution of the work.

The committee respectfully submit the Following resolutions:

Resolved, That 30,000 dollars, in addition to the sums heretofore appropriated, and reimbursable by the same fund, shall be appropriated for making the road lead ing from Cumberland to Brownsville.

Resolve That provision be made for the levying of toll sufficient to keep the same in repair.

Resolve. That it is inexpedient to appropriate money for erecting a bridge o ver the Youghoghany river, on the said road.

May 5 1812

UNITED STATES WESTERN ROAD

Proposals will be received till the twelfth day of July next, at the Sup erintendant's office, Cumberland; for making and completing that part of the road leading from Cumberland on the Potomac, in the State of Maryland, to Brownsville on the Monongahela; in the state of Pennsyl vania, which extends from the end of thirty-nine miles and twenty perches from Cumberland, near the west bank of the Youghagany river to the end of forty0five miles and two hundred and eighty perches from Cumberland, as the same has been laid out by the commissioners, with alterations since confirmed by the President of the United States, in conformity with the provisions of the act of Congress for that purpose.

Also, for the erection of a stone bridge over the Big Youghagany river of about two hundred and fifty feet in length.

Also, for the delivery of a sufficient quantity of lime for the construction of the said bridges and culverts.

Information will be given by the Sup entendant David Schriver, jr. respecting the manner in which the road and the said bridges are to be completed, the division of the road into sections, and all the particulars of the controcts.

A.J DALLAS,
Secretary of the Treasury
Treasury Department, June 10, 1815
June 28, 1815

UNITED STATES
Western Road.

PROPOSALS will be received by this subscriber, until the 23rd January next, for makingthe unfinished part of the Uni ted States Western Turnpike, between Cumberland in Maryland and Union town in Pennsylvania, comprising of a s???ce of about fifteen miles for the con struction of Bridges and other mason work, and also for the delivery of lime.

There being two locations, branching at about sity miles from Cumberland, to connecting again at Uniontown, the one made by the Superintendent, and the other by the commissioner hitherto app ointed, and these two locations having been connected by order of the gover nment and district marke, it is desired that proposals may be given for both routes. The different lines are plainly marked and both routes divided into sections the end of each of which is distincty marked with the number of the section.

It is deemed necessary to give a description of the work, as it is to be made in a similar manner (both road and mason work) to that already done. The grading holes made by the superintendent as well as those of the Commissioners, can be had by calling in the Subscriber, which will give any additional information that may be desired and shew a form of the contract that entered into.

A proposal may embrace one or more sections, UNINTELLIGIBLE. The public being anxious for the speedy completion of this road, the short ?? of the time may be a consideration as well as the price. As to guard against deception the Contractor is warned, that at the end of the time stipulated, the contract will be exacted from him; it is therefore requested that none may fix upon a shorter period than will enable him to fulfill his engagement.

For the convenience of persons in the neighbourhood of Uniontown, the subscriber will attand in Uniontown on the said 23 of January next.

DAVID SHRIVER.
Superintendant U States Road
Cumberland December 21, 1816
January 4, 1817

The Uniontown newspaper *Genius of Liberty* would regularly announce the news of the road.

23

The Genius of Liberty

AND FAYETTE ADVERTISER

VOLUME ISSUE UNION Total No. 506

To Travellers.

The subscriber informs travellers and the public in general that he has commenced keeping a public house of entertainment two and a half miles from Brownsviulle, on the greqt road leading from thence to Uniontown called the Western Inn, where there is a well of good standing water, in which a pump will shortly be fixed, where he intends keeping an assortment of good liquors and other accom modations for travelers and will give good attention to all who may be pleased to call upon him.

CUTHBERT WIGGINS.

April 12th 1815. Swnp

Was Stolen

OUT of the Bar Room of the subscriber, living on the top of Laurel hill, six miles from Uniontown, on the road leading to Cumberland , on the 27th of July last, A Large Switzer Silver Watch, double cased, winds in the fce and remarkably hard. The hour figures are large, heavy and old fashioned ' there is a circle of minute figures outside of the hour figures of the usual kind. She is engraved round the edg of the cases withch fit tight;' she has a large broad chain of very open work with small rings on each side of white &c yellow colors, and contains, at the lower end, two small chains, inlaid with small white stones, and had on when taken one straight and one crooked key. Any person securing the thief and watch, so that he can be brought to justice shall have 20 dollars reward, or for the watch only five.

John Slack.

August 2, 1815

GREEN TREE
Tavern

The subscriber respectfully informs his former customers, and those that may favour him with a call that he has lately removed from his former stand, to that lately occupied by Jacob Copeland, known by the name of the

BLACK HORSE TAVERN

on Front Street, in the borough of Brownsville, where he will be constantly enabled to entertain travelers in the best manner, behavior provided himself with a variety of the best liquors, bedding, and horse needs, the house is large and commodious, there is on the premise a wagon yard (enclosed), for the accom modation of waggobners and moving families; he hopes that by strict attention to merit a share of the public patronage.

JOSEPH T. NOBLE

March 6, 1816

FOR SALE.

THAT VALUABLE

BRICK house, in Uniontown in which mr. L. W. Stockton now lives, together with all the other buildings on the same lot of ground. For terms apply to John Lyon, Esq. In Uniontown or to the sub scriber in Wheeling, Va.

WM. WYLIE

Sept 11, 1827

GRAND CARAVAN OF LIVING
ANIMALS,

Will be exhibited at the house of Andrew Byers, in Union Town, on Saturday next, 26th inst. From 12 o'clock, M. to 5 o'clock Pm M. a full grown LION and LIONESS, both in one cage.

Two PANTHERS, male and female, both in one cage. Missouri Bear, Cougar from Brazil, a full grown African Leo pard, Sehtland Poney, and his rider Dan dy Jack, Col. Pluck, Saucy Jack, Lady Jane Ichneumon, Ant eater, &c.

Admittance 12 1/2 cents. 1829

Boarding School,
For
YOUNG LADIES

THR proprietara of the Brownsville Female Academy, respectfully inform the citizens of Fayette & Washington counties, that in consonant with the advice of their friends they have determined to reduce the terms of their school.

The branches of

English & Polite
LITERATURE

Which MR. AND MRS. WILLIAMS propose teaching assisted by the Rever end Mr Pfeiffer are:

Orthography, Reading, Writing, Arith metic, English Grammar, Geography, with the use of the Maps – History, Philosophy, Drawing and Painting on Velvet & Bristol Boards, and by Theorem, Music (Piano), Needle Work, plain and ornamental, and Rug Work.

They have also determined to confine their school to Young Ladies alone.

Their course of instruction will comm. ence on Monday the 2d of April, 1827, in the town of Brownsville.

April 17, 1827

300 Dollars
REWARD.

RANAWAY from the subscriber living in Breaton county, Va. On the night of the 3d inst. Six Negroes, called Jesse, Graham, Catharine, Mary, Harriet, Lucy, and Alphey....

They all belong to one family, and they are supposed to be lurking somewhere between Morgantown and Pittsburg. They took with them two horses, ...

Sept 5, 1826

Life along the National Road came alive.

24

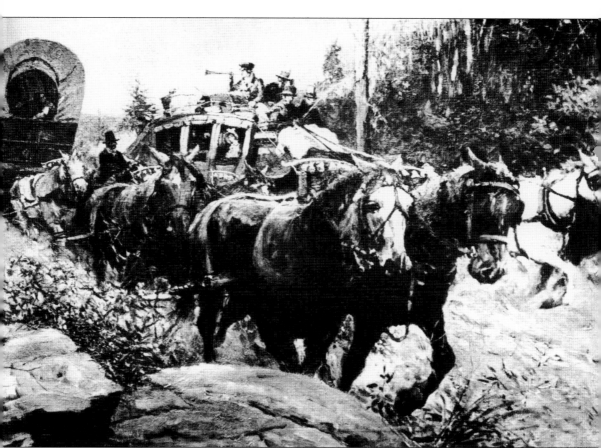

More than 200,000 people a year traveled the National Road in its heyday. They climbed the mountains during brilliant fall foliage and heavy white snow. They got malaria, which they called the ague, and died of milk fever. They carried the great cholera epidemic that began in India in 1816 across the National Road in 1833. They were terrified, but they never stopped. Wagon after wagon, stagecoach after stagecoach, they came.

Among the most colorful travelers were the drovers with their herds of sheep, geese, turkeys, hogs, or cattle. They ambled along "on the hoof," clacking and clattering, blocking the roadway especially at toll houses, where they had to be counted. When they became unsettled, off they would go—5,000 turkeys gobbling and screaming down the road. It took weeks, sometimes months, to reach their destination. (Smithwiick and French.)

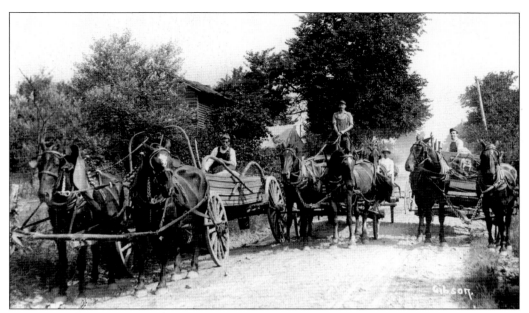

The most common travelers were the freighters, whose flatbed wagons were pulled along by six-horse teams. There were no items too fragile, such as Baltimore oysters, or too heavy, such as pianos, that they would not haul. (Uniontown.)

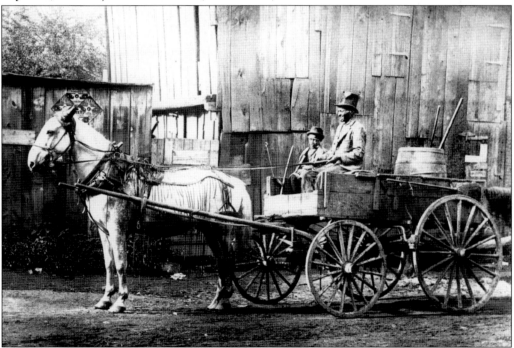

Named *Man-Eater, Devil-Bill,* and *Hatchet-Face,* the freighters fought, fiddled, and danced. If the road was impassable, they drove through the fields. When they overturned, everyone pitched in to right and repack the wagon. If they had an accident, they had to relinquish one of their bells. Arriving at the destination with "bells on" meant that the journey was safe. (Uniontown.)

The glory of the road belonged to the painted and ornamented stagecoaches with their silk plush interiors and cushioned seats. Back and forth they would travel between Uniontown and Washington ($2.25) or Washington and Wheeling ($2). The first stagecoach line on the road in Pennsylvania was Hill, Simms, and Pemberton, out of Hillsborough (Scenery Hill). The largest was Lucius W. Stockton's National Road Stage Line out of Uniontown. The last coach ran the road in 1894. (Harpers.)

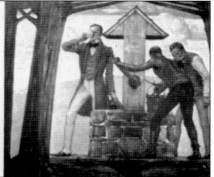

Keeping fast pace with the coaches were the express riders, who were never given the name but were a true Pony Express. They hauled mail over the National Road, changing mounts every few miles. They were established here by Amos Kendall, postmaster general, in 1835 and in the American Southwest as the Pony Express by Wells Fargo in the 1860s.

Over the road came families moving west in Conestoga wagons (built originally in Pennsylvania), with tools and food supplies tied firmly into place, goods arranged in barrels, and children running alongside. Traveling preachers came to praise the Lord, pray over the sick, baptize, confirm, and say prayers for the dead. Physicians moved from town to town to heal the sick, sometimes for a meal and a bed. Entertainers set up portable stages beside the road to entertain with jugglers, dancers, and storytellers. Local people thought nothing of walking five or six miles to visit a friend or to attend a corn husking or spelling bee. Sometimes, they would encounter a string of slaves tied together, walking the distance to their next destination. Other times, they would hide slaves from the men sent north to capture them. The entire American panorama went by. (Evans-Parcell.)

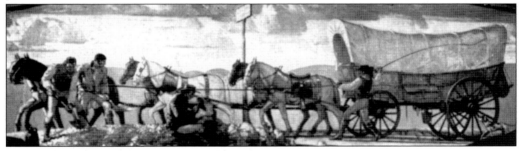

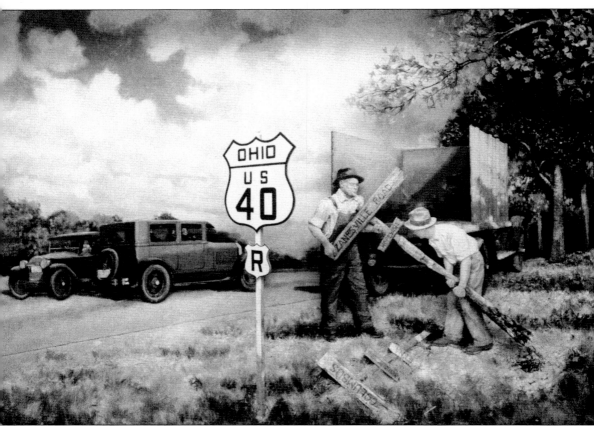

In the 1920s, Route 40 absorbed the National Road. Stretching from Atlantic City on the eastern seaboard to San Francisco on the West Coast, the new highway linked America. However, as the National Road did not follow the old American Indian paths or Braddock's Road exactly, neither does Route 40 follow the National Road. Sometimes in Pennsylvania, they lie side by side, as at Malden, Strabane, and West Alexander. Sometimes Route 40 detours around a town, as at Addison, Hopwood, and Centerville, or jumps a stream in a different place, as at the Youghiogheny and the S-Bridge. It is sometimes no longer the main street of a town, as in Brownsville and Washington. This image, one of dozens painted by Carl Rakeman for the Bureau of Public Roads in the 1920s, shows the Route 40 signs being erected. (RBHL-BPR-Rakeman.)

Three

THE NATIONAL ROAD
OVER THE MOUNTAINS

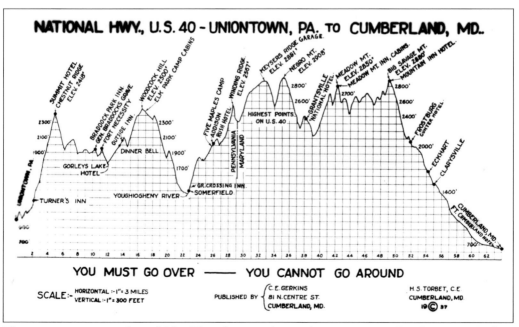

The mountains were formidable. They bore such terrifying names as Big Savage, Winding Ridge, and Devil's Half Acre. Sometimes, the winds blew down Chestnut Ridge at 50 miles per hour, and its 3-mile hill, always a nightmare, became a deathtrap.

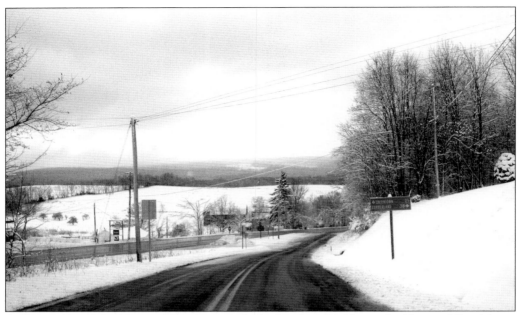

As Route 40 and the National Road approach the hamlet of Addison, the National Road (seen in a view looking east) veers left up over a hill while Route 40 continues in a straight line. They join a mile or so up the road, beyond Addison (once called Petersburg) and the first toll house in Pennsylvania. (Author.)

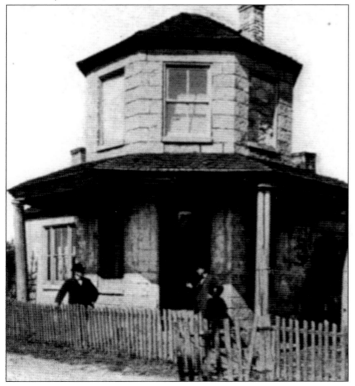

The Petersburg Toll House is the first toll in Pennsylvania (Toll Gate No. 1). It sits at the entrance to Addison (Petersburg). The tollgate posts that barred passage until payment was assessed were recently replaced opposite the toll house. The facility has been maintained by the Great Crossing Chapter of the Daughters of the American Revolution since 1919, and it is now in pristine condition. (Bruce.)

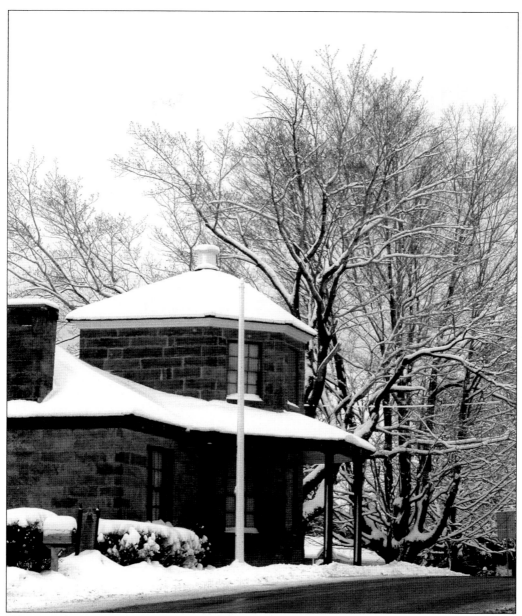

What a welcome site the first of Pennsylvania's six toll houses must have been to freighters and stagecoach passengers, especially on blustering winter days. The six-sided two-story building had an office, a kitchen, and a parlor on the first floor and a bedroom on the second. (Author.)

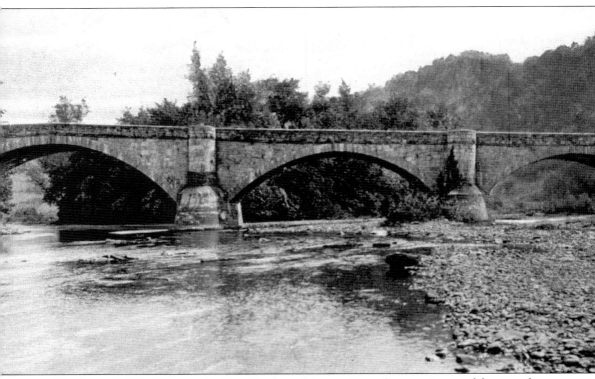

The Somerfield bridge over the Youghiogheny River at Great Crossing is one of the most famous bridges on the National Road. The three-span stone structure was dedicated on July 4, 1818, with Pres. James Monroe and a number of local Revolutionary War soldiers in attendance. Sadly, the Youghiogheny Reservoir, a federal flood project, inundated both the community of Somerfield and the magnificent stone bridge in the 1940s.

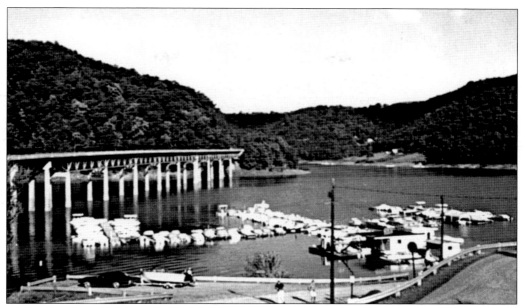

Yough Lake has become a great recreational area since its creation by the U.S. Army Corps of Engineers. In 1936, Pittsburgh was hit with the St. Patrick's Day Flood, so a dam was built over the Youghiogheny River, creating the 16-mile-long lake. The town of Somerfield was demolished and flooded.

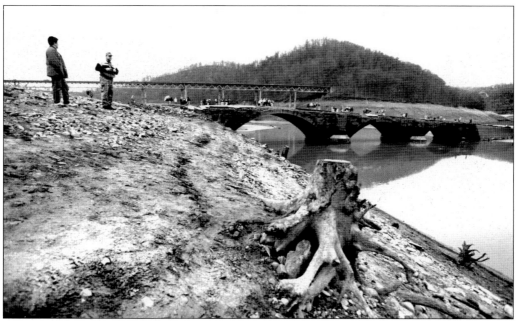

During drought, the Somerfield bridge reemerges like a ghost of the past. Where once stagecoaches and automobiles would speed across its span into the village of Somerfield, today those who are curious walk slowly over the waterlogged surface when low water permits, perhaps once in 10 years. To the credit of its builders, Kinkead, Beck, and Evans, it is still intact after decades under water. (O'Neill-PG.)

Once over the bridge, the National Road cut through the heart of Somerfield. The community was known for its hospitable inns and eccentric innkeepers. Cockfights and horse races were frequent occurrences, especially at Jockey Hollow, located a little west of town but still on the National Road. (Bruce.)

Known as the Endsley House during stagecoach days, when it was the headquarters of the Stockton line, this stone building was erected in 1818 by the same company that built the bridge. When early automobiles roamed the road, it became the Youghiogheny House. Now, it too is a victim of Yough Lake. (NPS.)

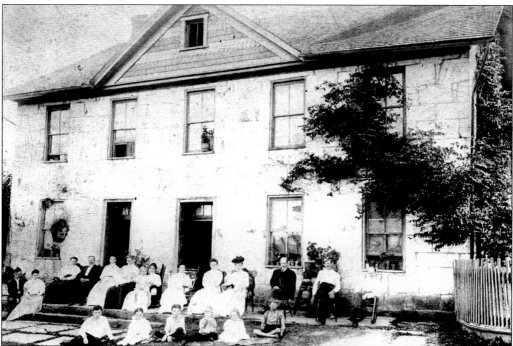

Thomas Brown had this tavern built in 1826 of native mountain stone, but it was run for many years as the Humberston House. The Humberstons, seen here, continued to operate it through the 1940s, when it was the Old Trails Inn. The hill, listed on maps as Woodcock Hill, was known locally as Humberston Hill, after the family at this tavern. The National Road snaked around the tavern. Route 40 straightens out the road. (Roberts.)

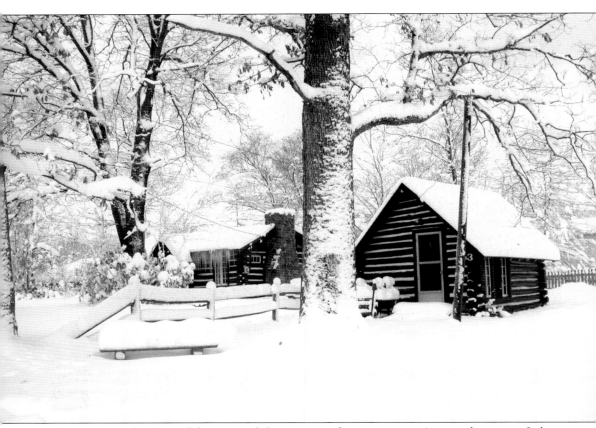

The motels and cabins of the automobile era enjoyed great success. Among them were Lebers Log Cabins, seen here during the winter. Additional automobile-era resorts along this stretch of road included the Mountain Emporium, which is now a craft center. In keeping with the mountain retreats of the past is the newly created Nemacolin Woodland, a world-class resort with spas, golf, polo, and even an airport. (Author.)

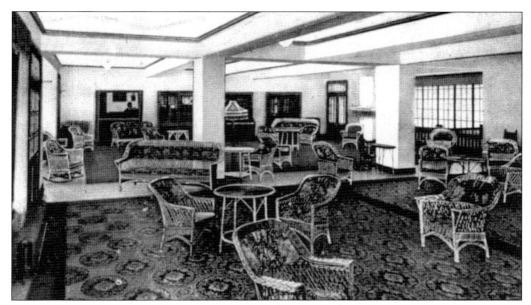

One of the greatest automobile-era resorts along the National Road was Gorley's Lake Hotel. It was founded by Uniontown's Charles Gorley, who created a mile-long lake open to the public for swimming and fishing in 1907. A lunch stand and bathhouse followed. This is the interior of the hotel.

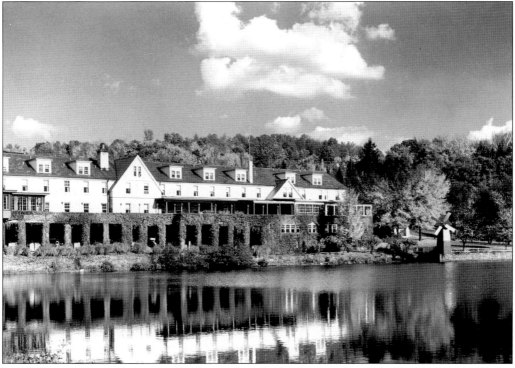

In 1920, construction began on the famous hotel, which opened on July 17, 1923. In 1957, the property was sold to the Society of Brothers (Hutterian Brethren). (NPS.)

Built in 1837 by Nathaniel Ewing, the stagecoach tavern at Farmington was purchased by Sebastian "Boss" Rush, who ran it like his own little kingdom. The Rush House entertained many of the travelers on the road, including famous singer Jenny Lind, who was returning from a successful tour of the West via the pike with the showman P.T. Barnum. (Author.)

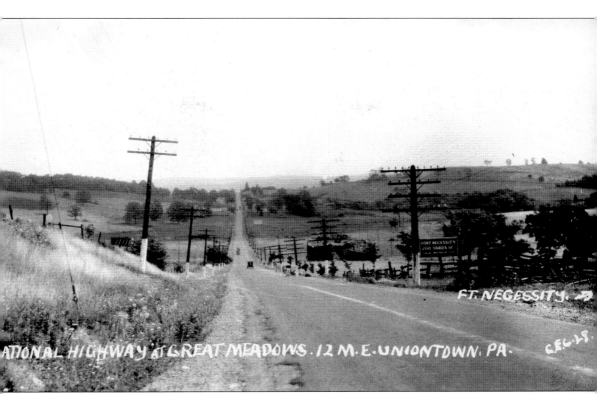

FT. NEGESSITY.

NATIONAL HIGHWAY AT GREAT MEADOWS. 12 M.E. UNIONTOWN. PA.

As seen here, the old dirt-and-gravel road had become a paved highway by 1932, and George Washington's hastily built fort had become a tourist attraction. This image places us at the Great Meadows, where George Washington built Fort Necessity after the encounter and death of Jumonville atop Chestnut Hill. On a rainy July 3, 1754, the attack came and Washington and his men were defeated. The expedition surrendered to the French on July 4, 1754. (NPS.)

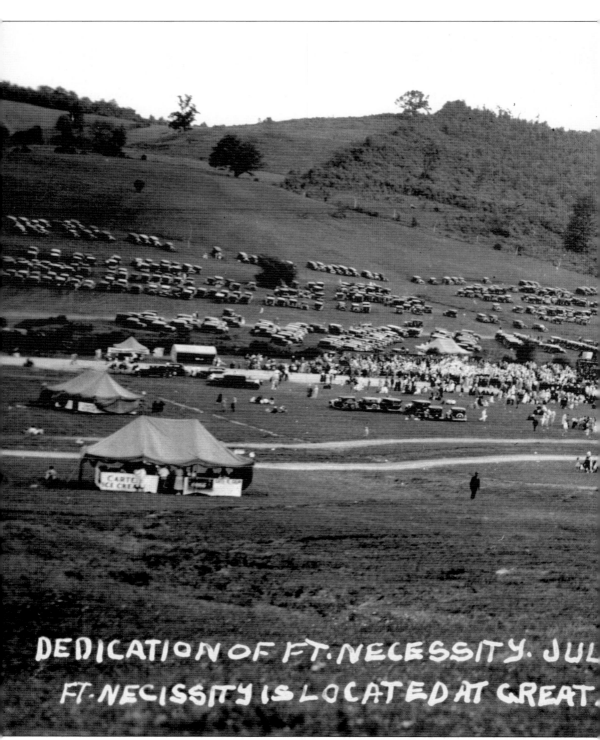

DEDICATION OF FT·NECESSITY. JUL
FT·NECISSITY IS LOCATED AT GREAT.

Fort Necessity National Battlefield was established as a national park on March 4, 1931, and was dedicated in 1932. When Washington's troops marched out of Fort Necessity in July 1754,

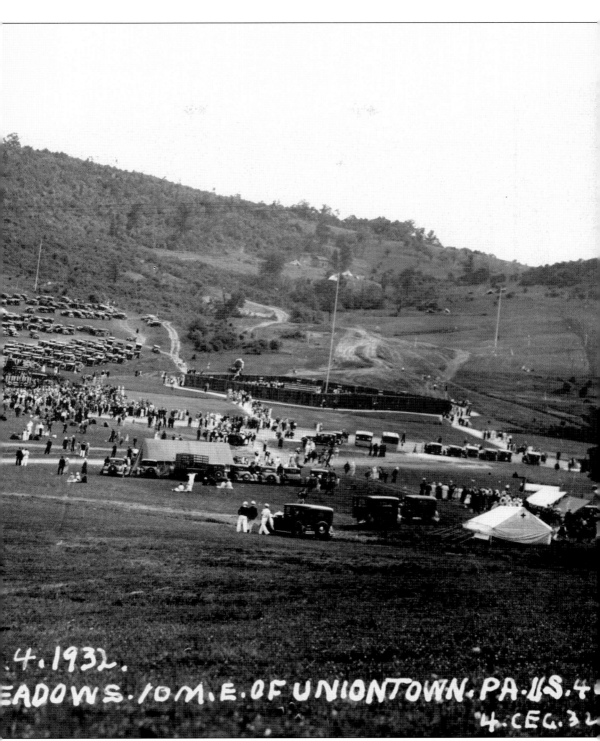

.4.1932.

EADOWS.10M.E.OF UNIONTOWN.PA.U.S.4

'4.CEG.32

the French burned the fort. Washington bought 234^1/$_2$ acres including the Great Meadows for speculation, thus preserving it for posterity. (NPS.)

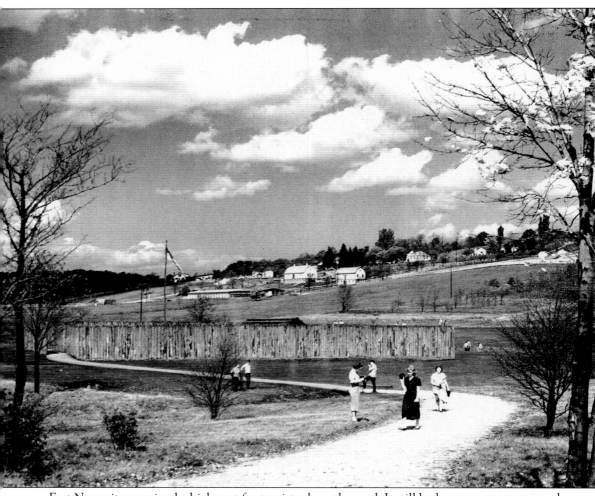

Fort Necessity remained a high spot for tourists along the road. It still had a square reconstructed fort. After additional excavations and research, it was discovered that the original fort was round and was therefore reconstructed once again in 1954. (Uniontown.)

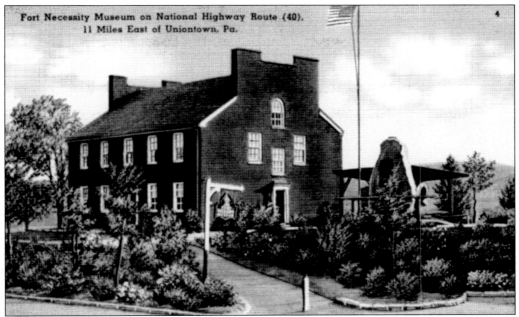

Erected in 1827 by Nathaniel Ewing on land once owned by George Washington, the Mount Washington Tavern was typical of the stagecoach taverns at that time. Today, the 11-room brick building is part of Fort Necessity National Battlefield.

A stagecoach stop existed every 12 miles and had beds with fresh linen and 25¢ family-style meals. Patrons shared beds, sometimes three and four to a bed. Stagecoaches would blow a horn to alert the innkeeper of their arrival, and the buckwheat cakes for which the mountain taverns were famous hit the griddle.

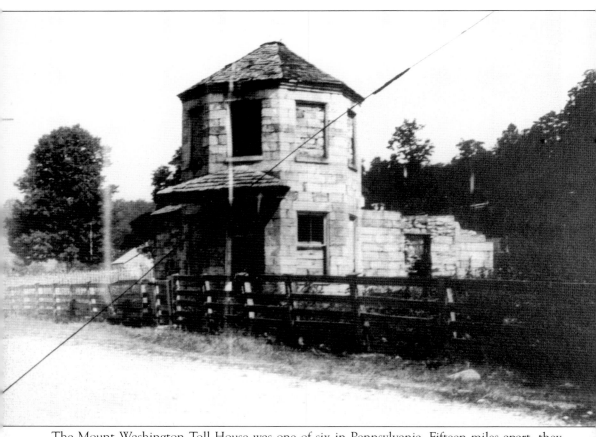

The Mount Washington Toll House was one of six in Pennsylvania. Fifteen miles apart, they included Petersburg (Addison), this one, Searight's, and those near Beallsville, at Washington, and before West Alexander. The two in the mountains were built of stone, the others of brick. A pole stretched across the road, and travelers were required to pay the toll before the pole would be turned (thus, the word *turnpike*). This toll house was torn down *c.* 1894. (Washington.)

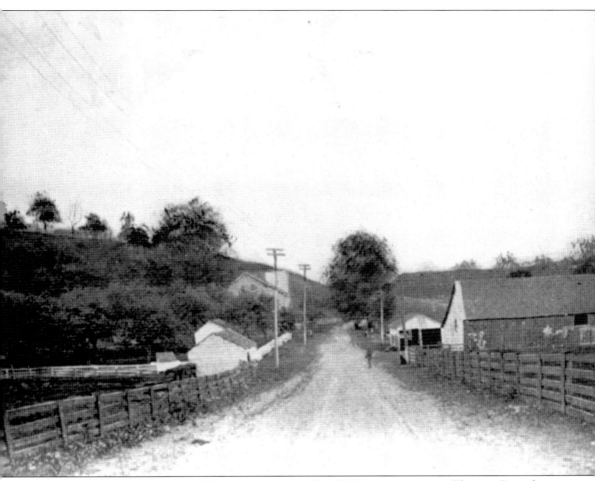

This image shows the National Road as it appeared c. 1894 on its way east. Thomas Searight, who wrote the definitive book on the National Road in Pennsylvania in the same year, says this view includes the Stone House and Darlington's. (Searight.)

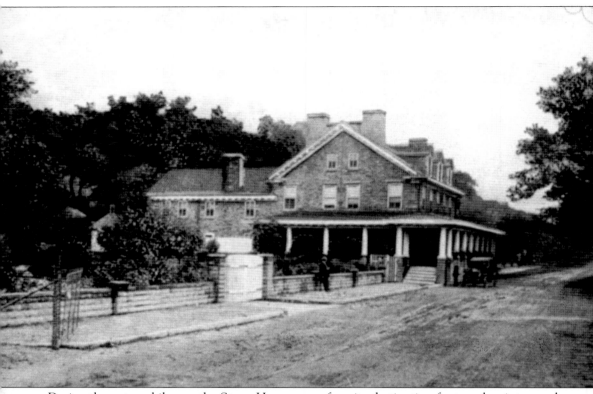

During the automobile era, the Stone House was a favorite destination for travelers interested in taking the medicinal waters of the Fayette Springs nearby. It had, and still has, all the attributes of a resort, including bowling alleys.

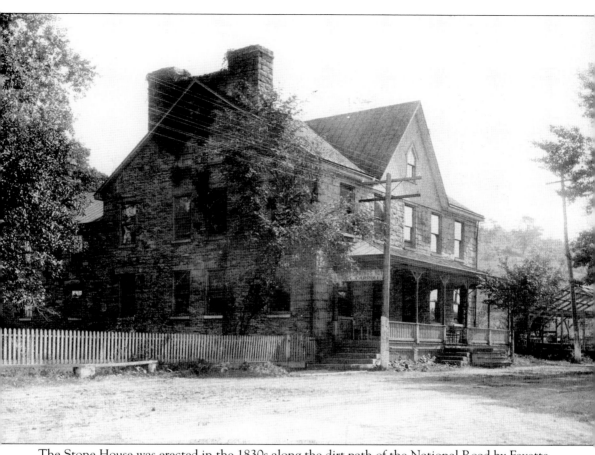

The Stone House was erected in the 1830s along the dirt path of the National Road by Fayette County politician and presidential hopeful Andrew Stewart. This picture was taken while the house was still a private residence. (Uniontown.)

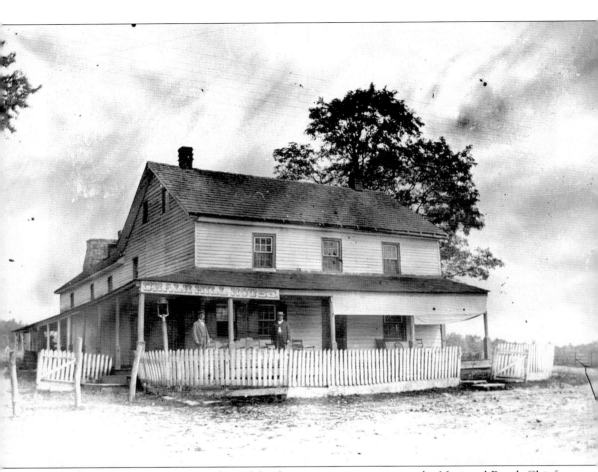

The Chalk Hill House was another of the famous mountain inns on the National Road. Chief Blackhawk breakfasted here on his way to Washington. Andrew Jackson not only slept here but also entertained 200 guests. It was erected in 1823. (Uniontown.)

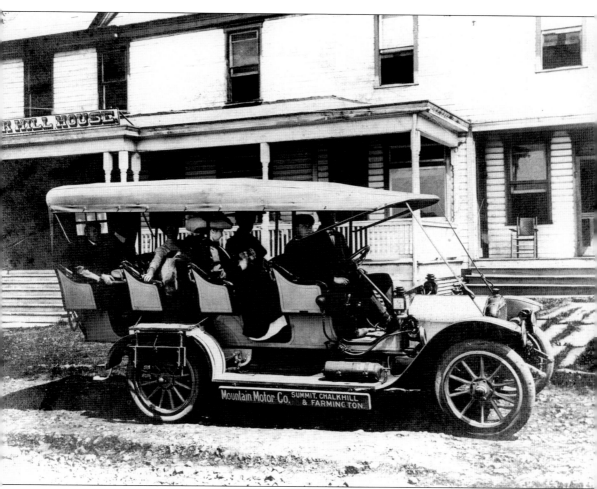

When the automobile took over the road, people who once traveled in stagecoaches or covered wagons transferred to motorized vehicles. Here, leaving the Chalk Hill House, is the bus of the early 20th century, a 12-passenger vehicle from the Mountain Motor Company. The community was named Chalk Hill by the men who constructed the road. They kept digging up chalk as they worked in the area. (Uniontown.)

In the 1940s, the Chalk Hill Motel hosted tourists visiting the mountain sites. Today, it is a site all by itself, as the owners have been collecting old machinery for quite a while. It is still an operating motel with 1940s and 1950s motifs, and its front yard is an outdoor museum of old machinery. (Author.)

Families lived along the National Road too. The Downers arrived to the area *c.* 1790 and built a log cabin at Chalk Hill. Jonathan Downer began this brick structure in 1823 and kept building it for 17 years. It is now a retail store. (Author.)

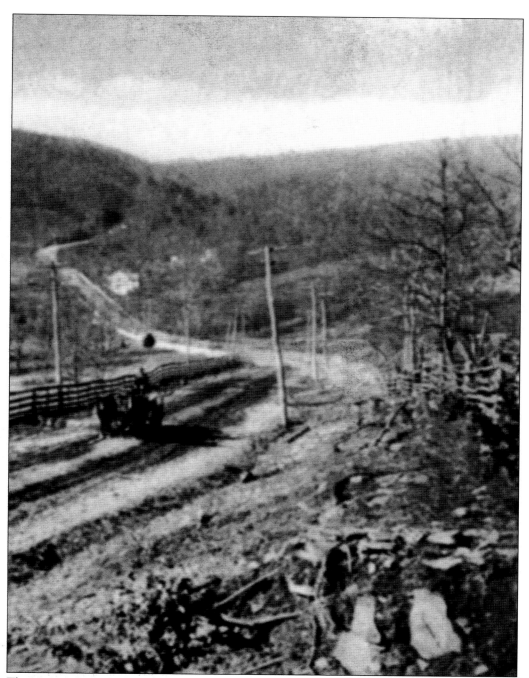

The National Road, seen in a view looking west toward Chestnut Ridge, is shown as it appeared in the 1890s. Chestnut Ridge is the last of the Allegheny Mountain fingers that run through southwestern Pennsylvania. It stands 2,500 feet above sea level and drops 1,200 feet to reach Hopwood below. Locals tend to call the ridge by a number of names, including Chestnut Hill, Laurel Ridge, and Laurel Hill, which confuses visitors, as Laurel Mountain is the next ridge east. (Searight.)

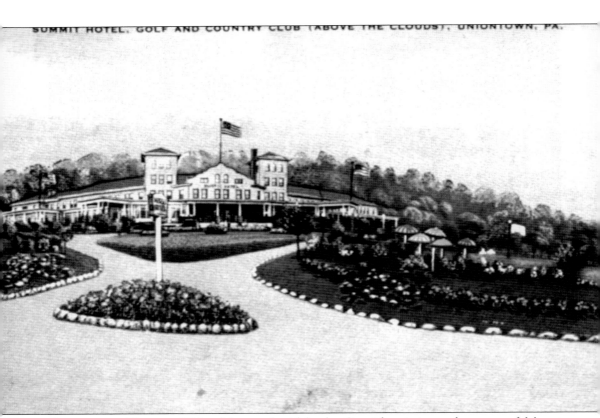

Sitting atop Chestnut Ridge (the south side), the Spanish mission-style resort of Mount Summit Inn was once famous as a honeymoon hotel (actor John Gilbert's bed is in the honeymoon suite). It was built in 1900 of native mountain stone to accommodate the tourists of the automobile era. The view is spectacular during all seasons of the year, and a huge veranda surrounds the hotel.

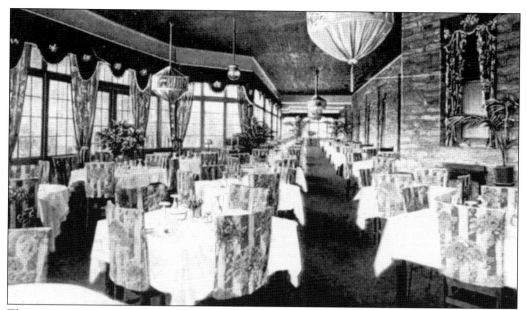

The view was everything, and the a la carte dining room, open all day, was and is encased in glass windows. All private rooms are outside rooms with magnificent views. The hotel boasted, "Freedom from Hay fever and Asthma assured. No railroad or trolley car noises. No smoke, heat or mosquitoes." At night, the view twinkled with thousands of coke ovens ablaze in the valleys below.

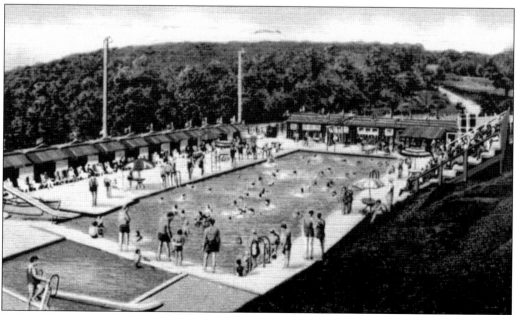

Early visitors enjoyed a lady's billiard parlor, game room, grill, barbershop, toilet room, piped gas, steam heat, electric lights, and running water tapped from artesian wells. Later, a heated swimming pool was added. It too commanded a magnificent view down the mountains. On a clear day, the skyscrapers of Pittsburgh could be seen 50 miles away.

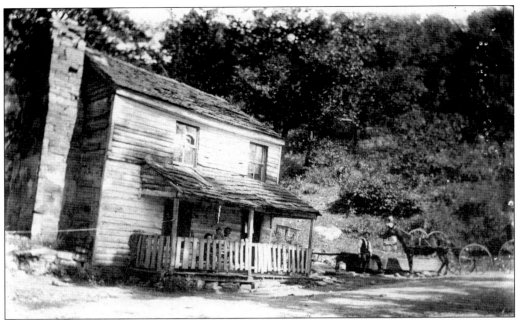

Heading up or down three-mile-long Chestnut Ridge was a formidable task. Halfway down the mountain, a natural spring became a popular spot called the watering trough. Early in the 1800s, horses pulling loads up or down the mountain had to stop to rest and drink. This building existed in 1840. (Uniontown.)

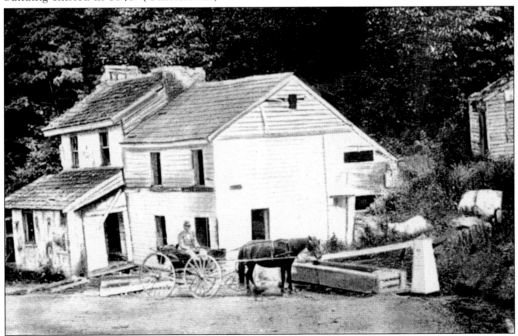

The water trough, seen here in front of the horse, was never open to all. If the owner of the home did not like your looks, you got no water. By the 1870s, the early house (far left) had an addition.

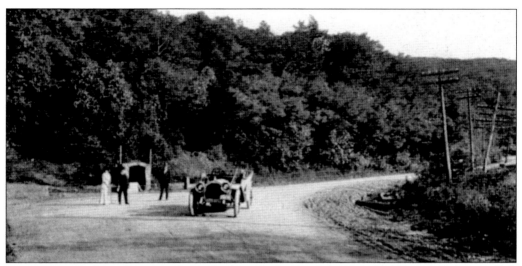

In 1901, a number of citizens from the Uniontown area formed the Water Mountain Club House and built another building, a cement watering trough, and a large outdoor oven where they often roasted ox, pig, or lamb. The image above shows the road in front of the trough.

Yet another building was erected as early cars had the same problem as horses. They had to stop at the trough for water and a rest, so a restaurant or nightclub was expected to thrive. Today, only the spring remains, still providing fresh water.

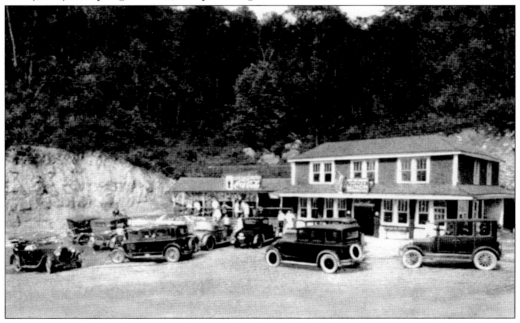

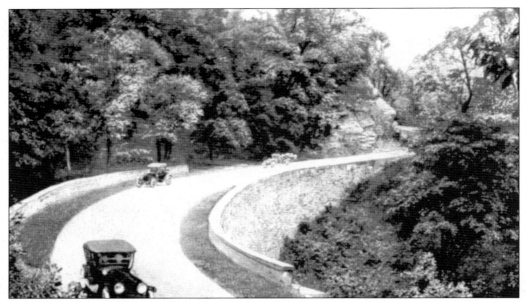

Near the bottom of Chestnut Ridge (at a point called Turkey's Nest because workmen found the nest while building the road), an original stone bridge carried the pike over a small creek.

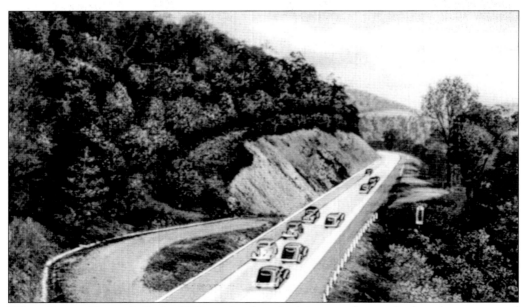

When Route 40 was built in 1923, technology had improved enough that the curves and switchbacks to maintain the grade needed on the National Road could be straightened, so the bridge was eliminated.

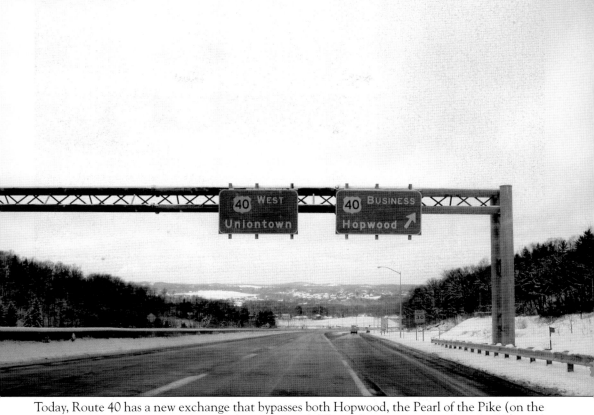

Today, Route 40 has a new exchange that bypasses both Hopwood, the Pearl of the Pike (on the right), and Uniontown, a mile or so down the road. The turkey nest is gone, but the National Road still runs through the heart of both communities. (Author.)

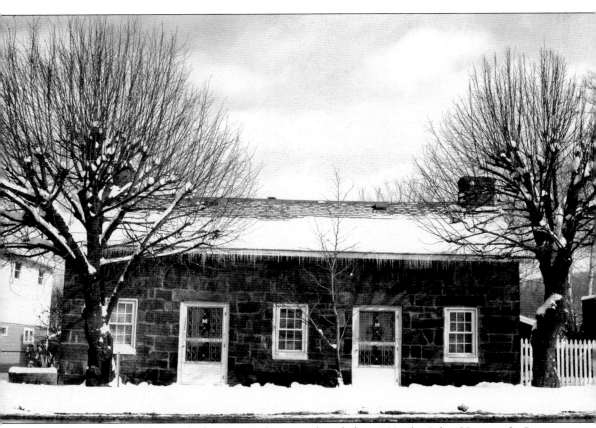

Hopwood, at the base of Chestnut Ridge, was founded in 1791 by John Hopwood, George Washington's aide de camp in the Revolutionary War. It has the largest number of stone buildings of any town on the National Road. Constructed of native stone and walnut beams harvested from Lick Hollow, the walls are two feet thick, making summers cool and winters warm. This building is known as the Hayden House. (Author.)

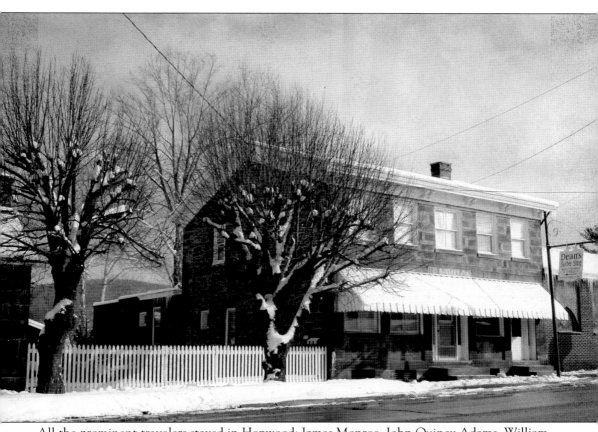

All the prominent travelers stayed in Hopwood: James Monroe, John Quincy Adams, William Henry Harrison, James Polk, and James Buchanan. To date, three of the Early Republican–style homes have been named to the National Register of Historical Places—Miller Tavern, Monroe Tavern, and Morris Hair Tavern (all in 1995). (Author.)

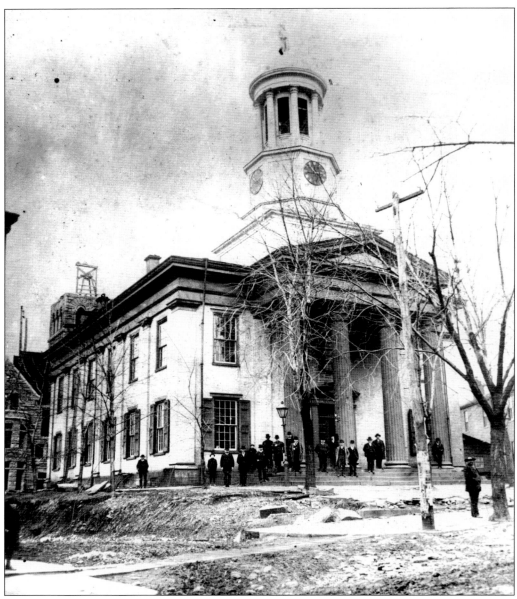

In 1768, Henry Beeson, a Quaker, visited Christopher Gist's Mount Braddock. He never left. On July 4, 1776, he created his town, which became known as Uniontown in later years. By 1784, it had a courthouse (also used as a school), a mill and miller, four taverns, and three blacksmiths. This courthouse burned down in the early 1890s. (BHS.)

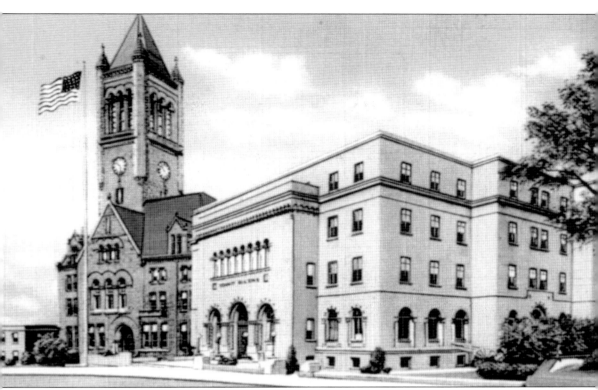

This Richardsonian Romanesque courthouse replaced the former one on the main street of Uniontown. With marble floors, a stained-glass skylight, and iron carved staircases, it is still a remarkable structure. By the time of its construction, the heyday of the road was over and the coke and coal era was about to begin.

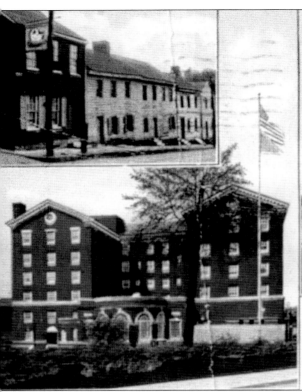
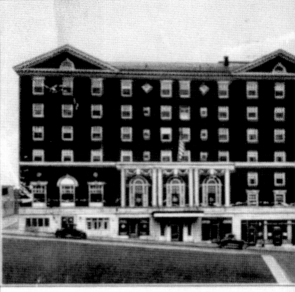

WHITE SWAN HOTEL
"ON THE NATIONAL HIGHWAY
UNIONTOWN. PENNSYLVANIA

The White Swan Hotel began as an inn in 1805 at the west end of Uniontown. It was owned by Thomas Brownfield, who had been a wagoner on Braddock's Road. When the National Road opened, he converted the inn into a wagon stand with two massive yards for the animals. A multistory hotel took its place during the coke and coal era. Today, it is a personal care home.

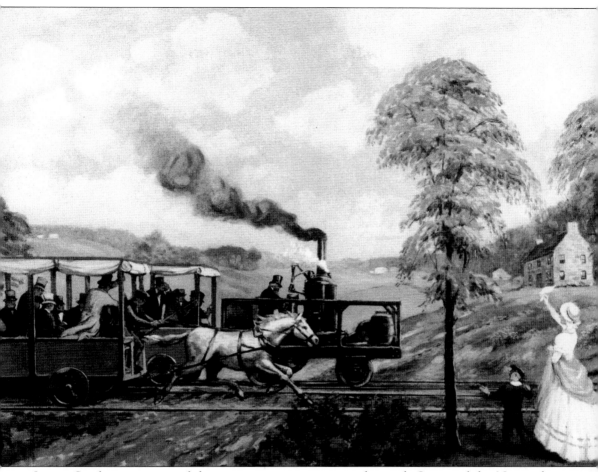

Lucius Stockton was one of the most interesting men on the road. Owner of the National Road Stage Company, the biggest line in Pennsylvania, he flew over the road in the Flying Dutchman, an exotic carriage, led by his sorrel horses, Bet and Sal. Uniontown and men like Stockton had staked their future on the National Road. When the railroad came, they would have none of it. In fact, this painting of a race between a Tom Thumb locomotive and a horse on August 28, 1830, replicates an escapade of Stockton. We know this because Stockton's daughter, at 91, told Earle Forrest of the race. When the road died because of the railroad, Uniontown had to build its own spur to be connected to the rail system through the coke and coal regions. (P.BHL-BPR-Rakeman.)

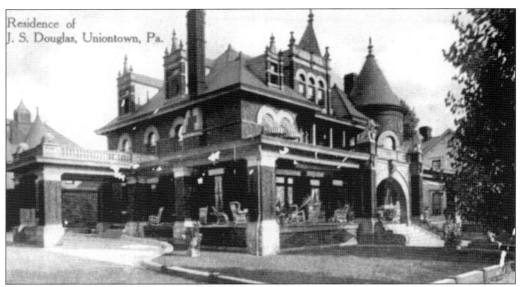

Residence of
J. S. Douglas, Uniontown, Pa.

The railroad and the coke and coal era grew together, and Uniontown became the heart of the new industry. By 1901, Uniontown was enjoying a building boom. By 1907, Uniontown (population 10,000) had 13 millionaires. Homes like the J.S. Douglas residence flanked Route 40, not the National Road, as it passed through the city.

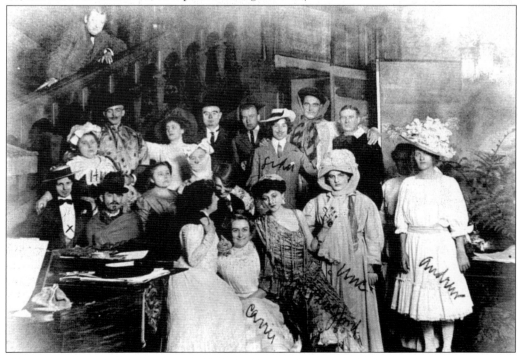

Most of this success was due to Josiah van Kirk Thompson (on the stairs), president of the First National Bank of Uniontown. Thompson competed with Andrew Mellon, Henry Clay Frick, and Andrew Carnegie of Pittsburgh for the coal fields along the National Road. Unlike them, he paid his employees well and gave a straight and honest six percent on loans. (Uniontown.)

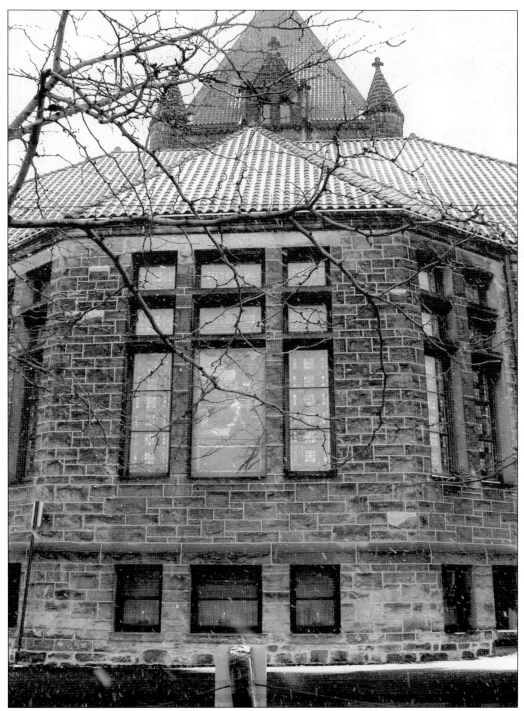

The Richardsonian Trinity United Presbyterian Church, with its Tiffany windows, was enriched by Josiah van Kirk Thompson's success. The patrons of its hand-carved pews and Austin organ were scandalized when Henry Clay Frick wanted the coal mines Thompson owned. (Author.)

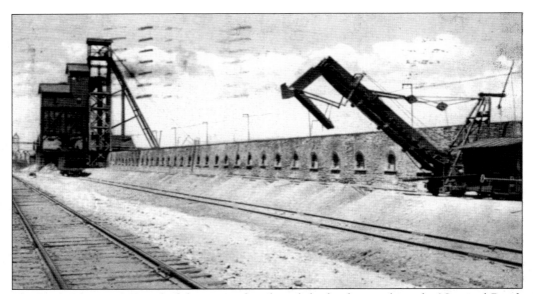

The Leith Mine was typical of the mines that dotted the landscape along the National Road. Here we see the old coke ovens that would glow at night with the burning coal. When Josiah van Kirk Thompson refused to sell to Henry Clay Frick, the battle was on. Frick used his influence on Pittsburgh bankers, especially Mellon.

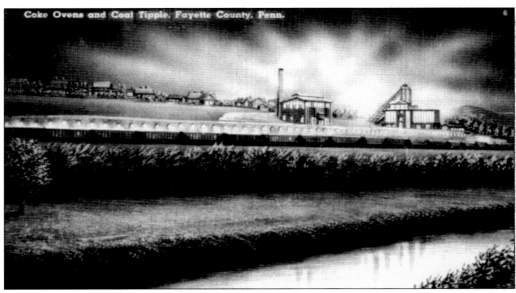

The good people who worked the mines lived in coal patches similar to the one seen here. With names like Searight, Alicia, Vesta, and Brier Hill, they dotted the road. People worked in the mine, bought goods in the company store, and lived in company homes. They were paid in script.

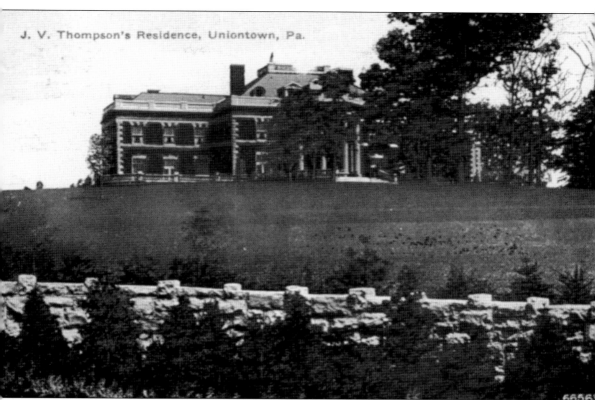

J. V. Thompson's Residence, Uniontown, Pa.

Oak Hill, the honeymoon home of Josiah van Kirk Thompson and his second wife, Hunny (page 60, back row, third from left), was sold. Sitting atop a hill along Route 40, it was furnished in a $1 million spending spree through Europe, Africa, and the Far East (1903). By 1917, Thompson was bankrupt ($70 million gone). Henry Clay Frick and his Pittsburgh industrialists bought up the coal lands for a fraction of their value. Oak Hill and its contents **went** on the auction block.

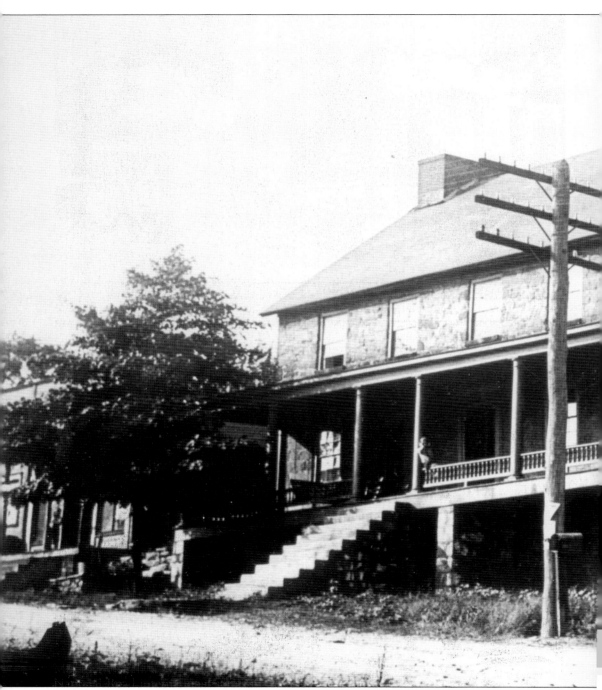

Searight's Tavern was one of the most famous of the 294 taverns between Baltimore and Wheeling. It stood where the National Road crossed a drover's trail to Virginia, and it had a livery stable, wagon maker's shop, and blacksmith's shop. It became a meeting place for locals, and dances were served up along with good food and drink. They could not gamble or overindulge in spirits, but patrons could politick. By 1840, Searight's was the acknowledged

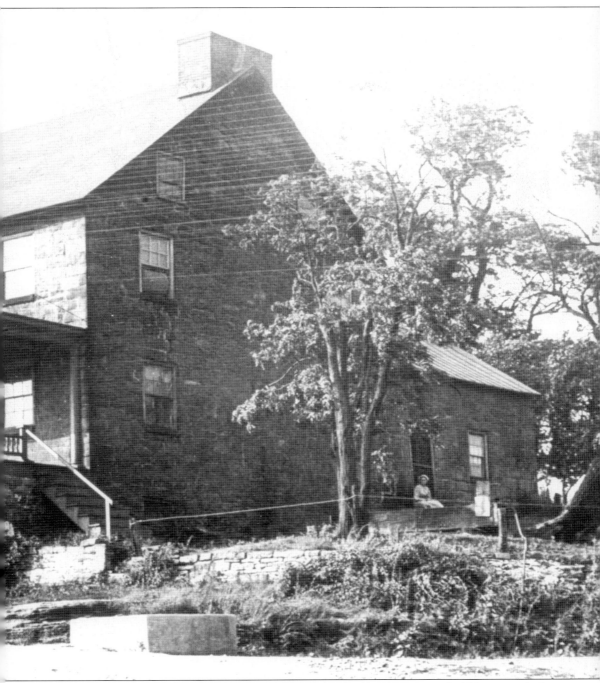

center of Democratic political life. County meetings and conventions were held here regularly. William Searight, the owner, was a staunch Jacksonian Democrat. His politicking was rewarded with a two-term post as commissioner of the Cumberland Road (with a salary seven times greater than the norm). The tavern became a private home and burned when a furnace was installed *c.* 1940. (NPS.)

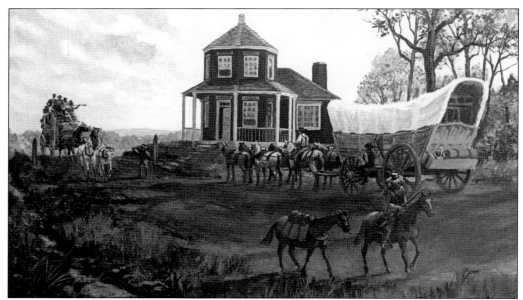

Searight's Toll House, the No. 3 gate, is one of four toll houses constructed of brick. It was built in 1835. This painting by Ray Forquer of Washington shows it as it must have appeared when it was first constructed.

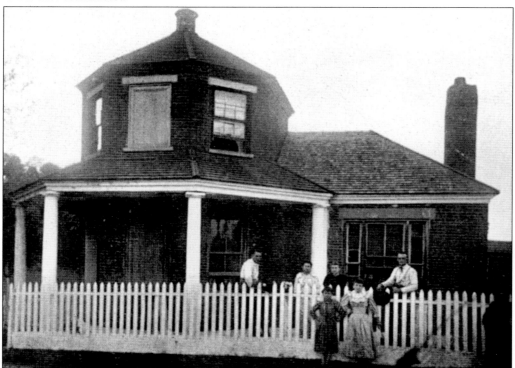

Named after William Searight, the toll house (seen here in the 1890s) remained operative until 1905. Legend says it was blown up by a group of striking coal miners during the many battles fought in this area for decent wages and improved working conditions. (Searight.)

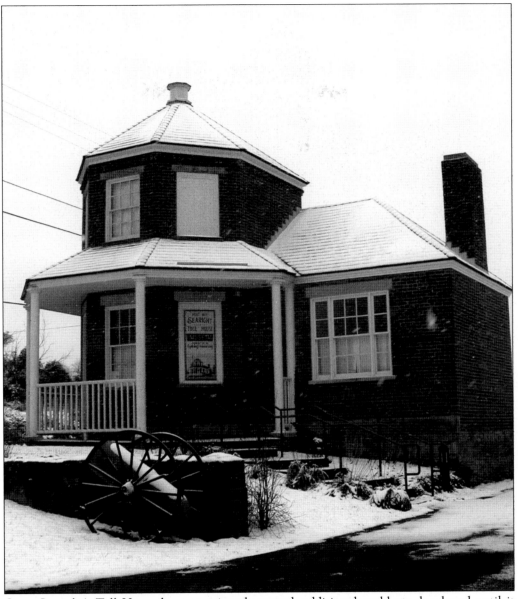

Once Searight's Toll House became privately owned, additional problems developed until it nearly fell to ruin. It was rebuilt and restored in 1966. Seen here in 2003, it is now owned by Fayette County and is operated by the Fayette County Historical Society. (Author.)

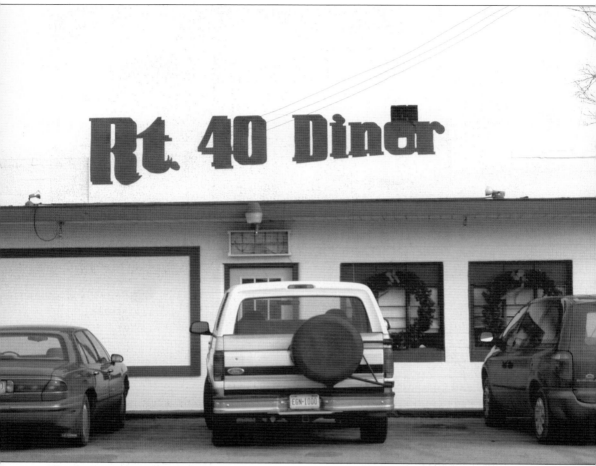

The Route 40 Diner, a group of gift shops, and an abandoned 1940s-style motel have replaced the outbuildings of the Green Tree Tavern, probably the oldest tavern on the National Road in Pennsylvania. The Green Tree Tavern was run by Abel Colley. The tavern straddled the road with the tavern on one side and Colley's brick home on the other. (Author.)

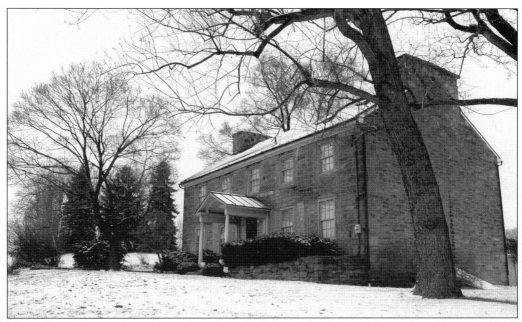

A few miles later stands the Hatfield Tavern. Hatfield bought the tavern and ran it from 1852 to 1855 as a stop for the Good Intent Line. It was visited by Polk, Jackson, and Clay, who all knew it was a perfect vehicle to "stump." Stagecoaches would blow a horn just before a tavern to alert the innkeeper of their arrival, and the cooks would fire up the kettle. (Author.)

When the automobile arrived on the National Road, so did a new icon—the gasoline station. It was this type of station that serviced tourists during the automobile era of the road. Many of these buildings remain, as much a testimony to travel as the old taverns. (Author.)

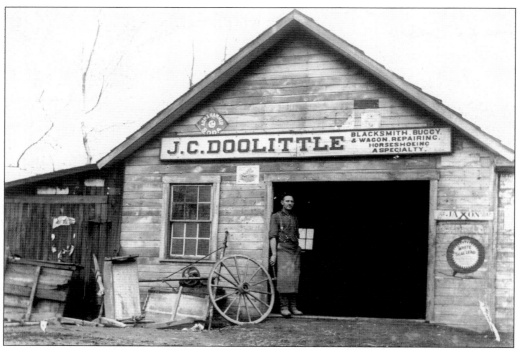

Gas stations replaced blacksmith shops like this one near Uniontown to keep the traffic moving along the road. Often found around taverns or the outskirts of towns, blacksmith shops fixed everything from wheels to reins to seats. (Uniontown.)

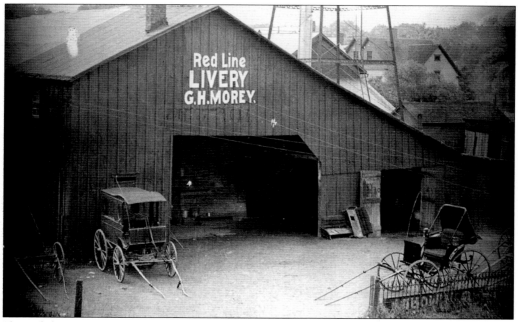

If you did not own your own rig and wanted to rent one or just needed repairs, you would go to a livery and rent a carriage or a surrey. They were the forerunners of "rent a wreck" and other agencies. (Uniontown.)

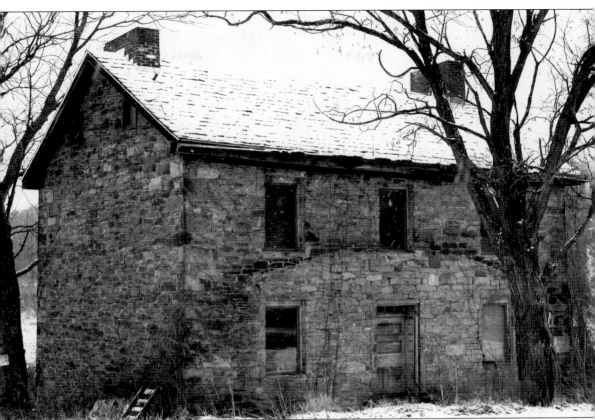

The Georgian-style Peter Colley Tavern, erected in 1796, stood along Burd's Road. It serviced noisy drovers and freighters who needed holding pens for animals and security for freight. It was erected by Pete Colley, who made sure the men "minded their p's and q's," as the innkeeper kept track of their pints and quarts on a slate near the bar. Nearby is the wooden barn, in very poor condition, but one of the few remaining wooden barns that saw the heyday of the National Road. (Author.)

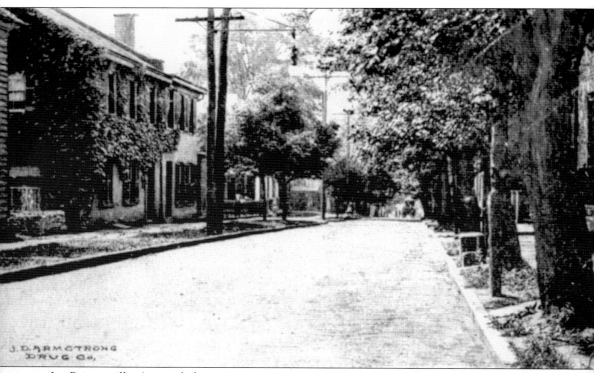

In Brownsville (one of the most important towns on the pike), the three arteries—the Nemacolin Path, Burd's Road, and the National Road—converge and become Front Street, the oldest commercial-residential district west of the Alleghenies. Members of the Whiskey Rebellion met here on July 27, 1791, as the rebellion was just beginning, and again on August 29, 1794, as it was coming to an end. Part of the North Side Historic District, Front Street is still lined by grand old homes such as the old Brownsville Academy on the right and the ivy-covered home of Philander Knox, secretary of state in the Taft administration, on the left. (BHS.)

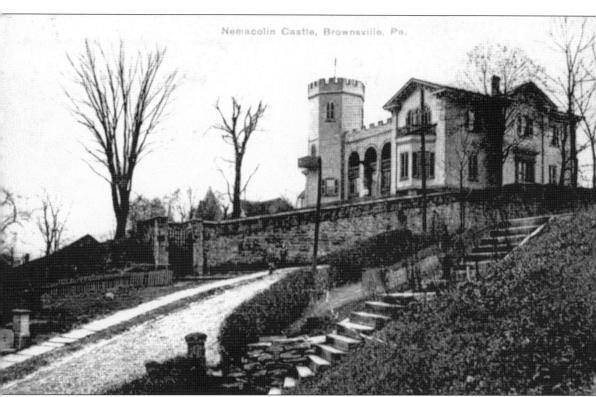

At the foot of Front Street, as the old Nemacolin Path tumbles down the cliff to the Monongahela River, is Nemacolin's Castle. Originally the site of Fort Burd, the location became Jacob Bowman's trading post in 1786. Bowman lived in the trading post with his wife, and as their family grew, the trading post was expanded and modified. The turret was added by one of Bowman's sons. The building now has 22 rooms, and the interior contains the original trading post, marble fireplaces, chandeliers, and a balcony with a spectacular view of the Monongahela River and valley. The castle is owned by Fayette County. It is being restored with funding from the National Road Heritage Corridor grant program through the DCNR, county dollars, and private donations. It is operated by the Brownsville Historical Society.

Market Street, two streets north of Front Street, is the National Road (and Route 40). Lining the street in this view looking west are the original commercial buildings of the 1800s, when the National Road was in its heyday and Brownsville was one of the most important transportation centers in the United States. The Monongahela National Bank moved from Front Street to this new commercial center. Searight opened a dry goods and grocery store here in 1864. The businesses along the street included a shoemaker, drugstore, chairmaker, and several taverns. Lafayette paused here and spoke to the citizens from the door of Brashear Tavern (right). As it moved west, Market Street just "fell" off the cliff down to an area known as the Neck. (BHS.)

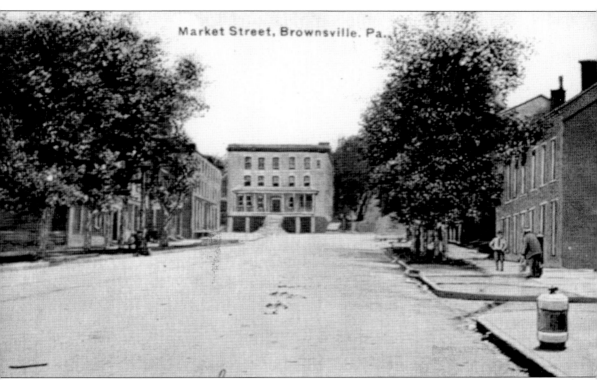

Market Street, Brownsville. Pa.

At the top of Market Street was Workman's Tavern, which was built in 1797. It later became Girard's (seen here). Workman's was a stop for Stockton's coach line. Andrew Jackson was a patron of Workman's Tavern, and crowds often gathered upon his arrival to petition him for favors and to listen to an impromptu speech. The width of the street remains the same today, wide enough for Route 40 to form a four-lane highway as it continues over the high-level bridge and eliminates Brownsville's lower sections.

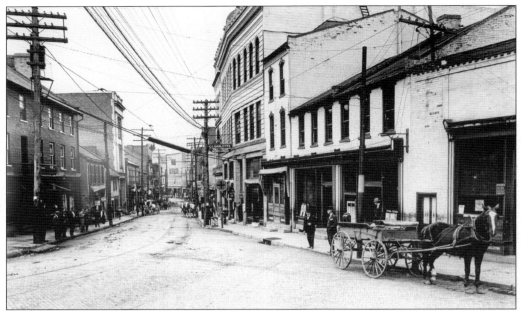

The National Road rides the cliff's edge down to Brownsville's downtown, named a historic district in 1993. Called "the Neck" because of its precarious location, it remained a bustling center of transportation for 200 years. It was here along the river that travelers would trade in their Conestoga wagons for flatboats and sail to Pittsburgh and beyond. (Washington.)

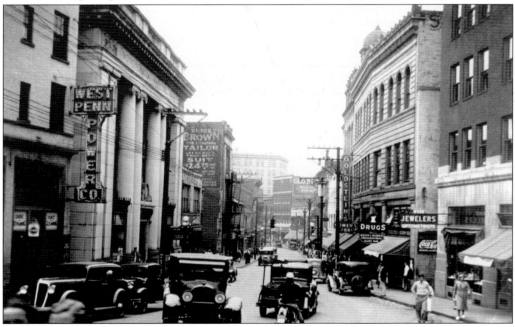

The face of the Neck changed with the arrival of Union Station (right). In the 20th century, it was the railroad that hauled the loads. This time the cargo was not people moving west but coal and coke from the Klondike coal fields of Fayette County to the steel mills in Pittsburgh. The Monongahela Bank (left) moved once again from upper Market Street to the Neck. (BHS.)

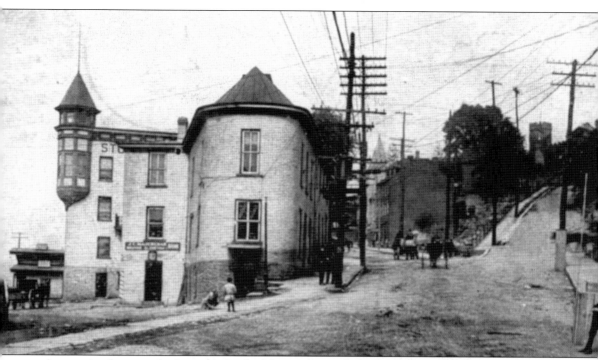

As seen in this view looking north, the Nemacolin Path (right) and the National Road (left) met at the Neck at the Flatiron Building. The building was constructed in 1830 and is the oldest structure on lower Market Street. Shaped like a clothes iron, it functioned as a post office (seen here) until 1920 and then as the first library in town, a trolley stop, a tailor shop, diner, bank, meat market, insurance business, and finally dentist office. Slated to be demolished, it was saved and is now a visitor's center and art gallery. (BHS.)

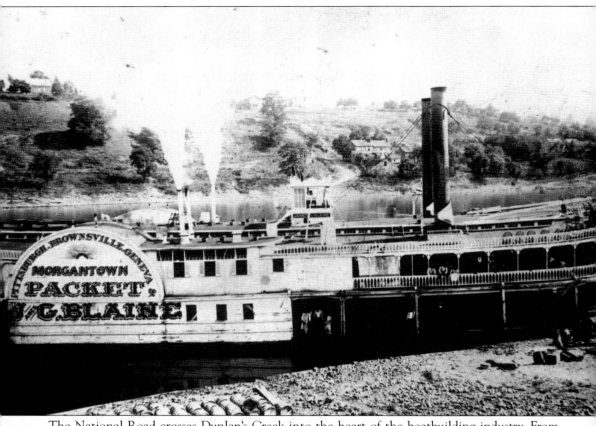

The National Road crosses Dunlap's Creek into the heart of the boatbuilding industry. From 1844 to 1852 (the heyday of the road), some 200,000 passengers were embarked at Brownsville, where the Lewis and Clark expedition may have had some of their flatboats built. The *James G. Blaine*, seen here, is one of dozens of boats built in the shipyards. Capt. Henry Shreve, a local boy, took the Brownsville-built steamer *Enterprise* on the first round-trip navigation of the Mississippi watershed system. (BHS.)

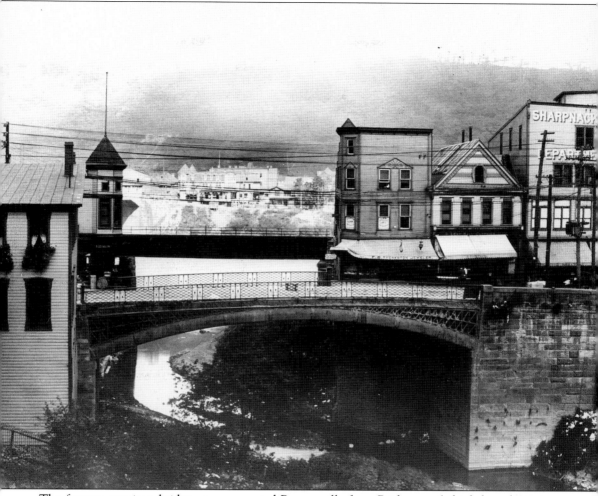

The famous cast-iron bridge once separated Brownsville from Bridgeport (which later became one community). The first bridge was erected here in 1794 along the Nemacolin Path, which ended at the river. The second, a chain bridge, collapsed under a freight wagon, which tumbled into the creek. This bridge, erected in 1836–1839 and seen here in 1911, is the first rib-fixed metal-arch cast-iron bridge in the United States and is a National Historic Civil Engineering Landmark (1969). (Lacock-Washington.)

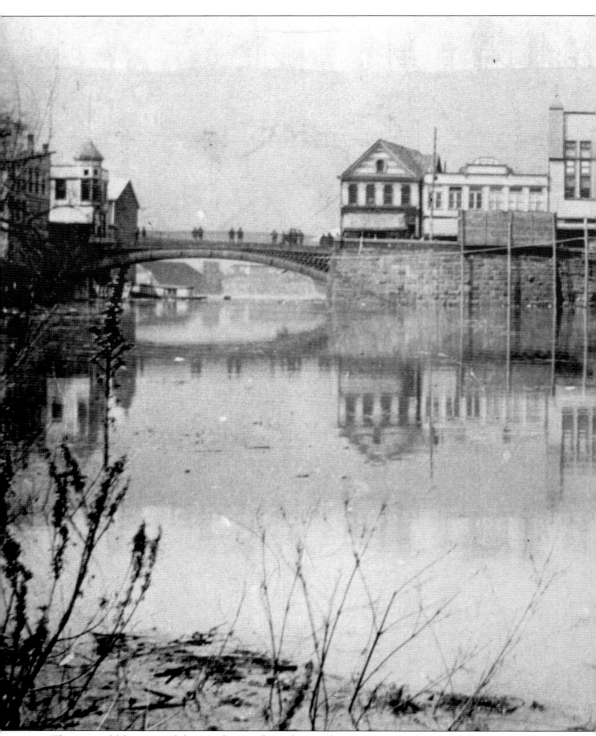

This incredible view of the Neck as it flowed over the cast-iron bridge was taken *c*. the 1840s.
It shows how slim the spit of land was and how some of the buildings had to be built on stilts.

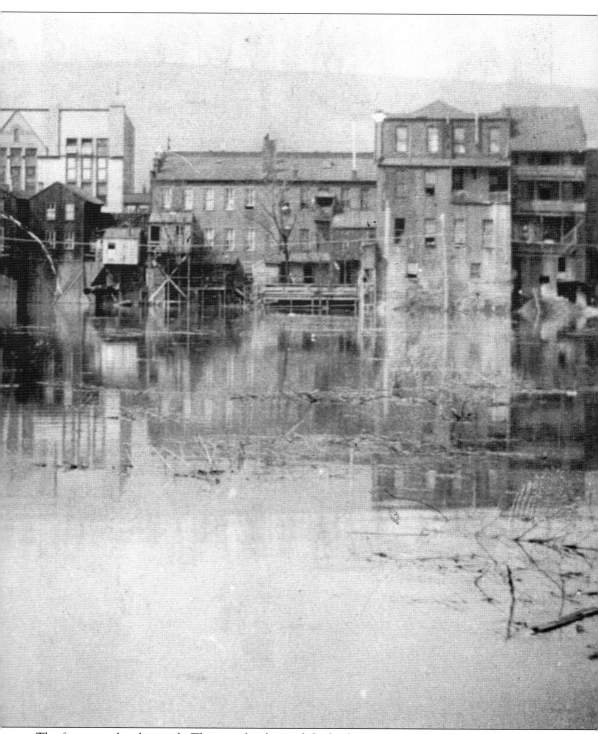

The foreground is the creek. The river lies beyond the bridge on the other side of the buildings. More land was reclaimed by landfill in later years, and a whole downtown emerged. (BHS.)

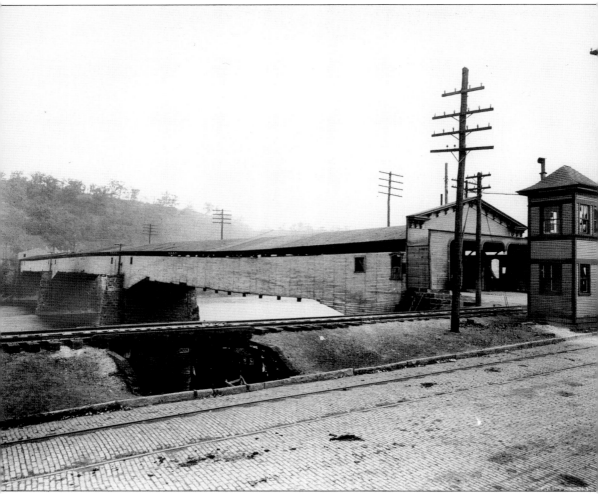

A magnificent covered bridge carried the National Road over the Monongahela River to West Brownsville and Washington County. The 600-foot span replaced Krepps' Ferry in March 1830 as the first bridge across the Monongahela. In *The Old National Road*, Robert Bruce said the riverfront at Brownsville was "one of the most historic crossings on the old pike." In fact, an oft repeated quote maintains, "Pittsburgh might amount to something if it weren't so close to Brownsville." (Lacock-Washington.)

Four

THE NATIONAL ROAD
THROUGH THE PLAINS

In 1910, the old covered bridge was condemned by the War Department, and a steam ferry took over while the construction of a new bridge began. Built in 1914, the 519-foot metal-truss Intercounty Bridge (shown here) was refurbished in 1987. (BHS.)

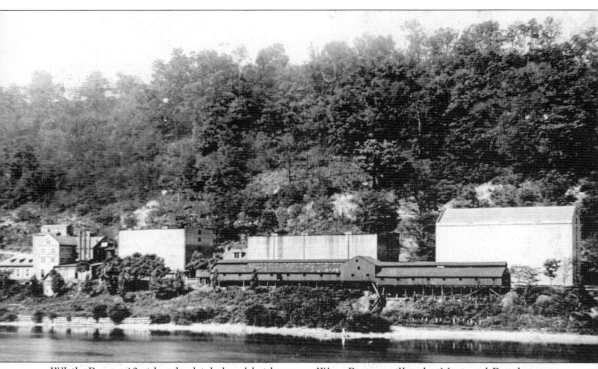

While Route 40 rides the high-level bridge over West Brownsville, the National Road crosses the Intercounty Bridge, jogs south, and passes the Sam Thompson Distillery. This whiskey, like Monongahela Rye, enjoyed great popularity before Prohibition. This c. 1900 photograph shows the distillery and its cattle barn. The cattle were fed the mash left from the distilling process. The Nemacolin Path ended at the river, and the Mingo Path takes the road through Washington County. (BHS.)

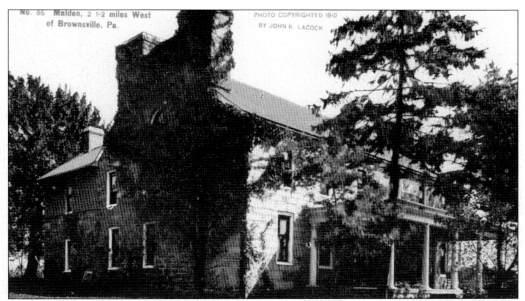

After climbing Indian Hill, the road arrives at Malden. Built in 1822 by John Krepps, the Malden Inn (Kreppsville Inn) was a wagon stand. With its stone barn, it is one of the finest examples of early-19th-century stone architecture on the road. Meals at such establishments would have included buckwheat cakes, johnnycakes, bacon, eggs, fried squirrel, venison, and fresh oysters.

Route 40 runs in an almost straight line through Washington County, while the National Road, always mindful of grading, twists and turns like a slithering snake around it. This loop bypasses Centerville, one of the original pike towns created exclusively to serve travelers along the road. (Author.)

Laid out in 1821, Centerville is the halfway point between Uniontown and Washington. Centerville Historic District was named to the National Register of Historical Places in 1996.

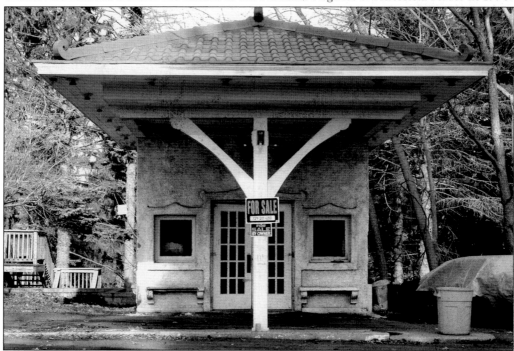

Tucked into the row of houses is a gas station with a Spanish-tile roof, perhaps the most picturesque of all the old stations along the road. Attendants in all these stations would give full service without any extra charge, and a person never had to get out of his car to have gas pumped, oil added, tires checked, or windows washed. (Author.)

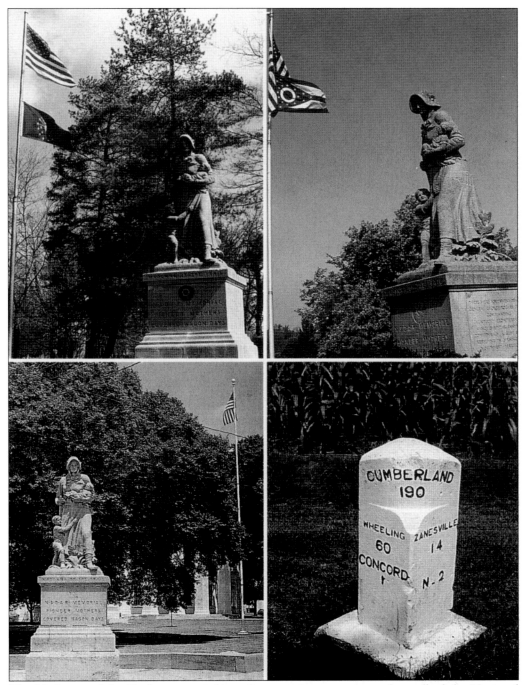

The Madonna of the Trail was created in tribute to pioneer women who walked the National Road on their way to the West. There are 12 duplicate statues in 12 states along Route 40. The 10-foot-high 5-ton statue, done by St. Louis sculptor August Limeback, depicts a tough pioneer mother with a musket in one hand and a baby in the other, wearing homespun, a sunbonnet, and sturdy boots. Clinging to her skirt is her son.

Long gone, this toll house was built just east of Beallsville. The town itself was settled in 1774, but it was laid out by Jonathan Knight in 1819 as a pike town to straddle the road. Knight was the civil engineer who built portions of the National Road. On the east end of town (the north side) stood Keys Tavern, a wagon yard kept by Andrew Keys. (Washington.)

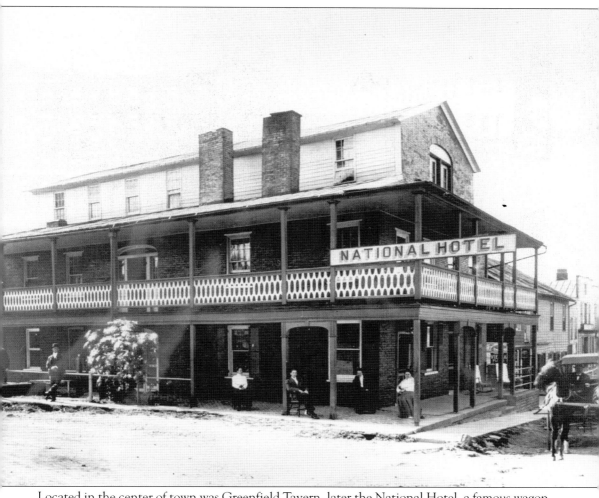

Located in the center of town was Greenfield Tavern, later the National Hotel, a famous wagon stand that served that rare drink, a cup of coffee. William Greenfield, a banker, established the Beallsville Savings Bank in his tavern and issued his own notes. During the automobile era, the tavern was known for its chicken and waffles and was again a popular stop. (Washington.)

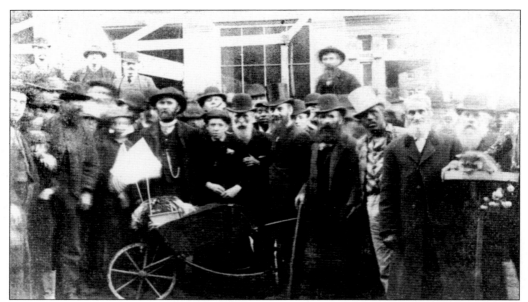

Beallsville, like all towns along the road, loved its politics. Two residents made a bet on the presidential election of 1888. They agreed the loser would push a rooster or a raccoon along the road and lay it on the courthouse steps in Washington. Well, William Harrison was elected, and the Democrat pushed a dead rooster in a baby carriage along the National Road on November 12, 1888. (Washington.)

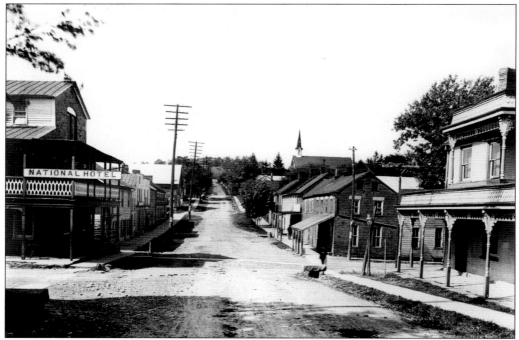

The view looking east along the National Road in Beallsville appears almost the same today as it does in this early-20th-century photograph. The view is the same, but the people, the shops, and the bustle of the National Road are gone. (Washington.)

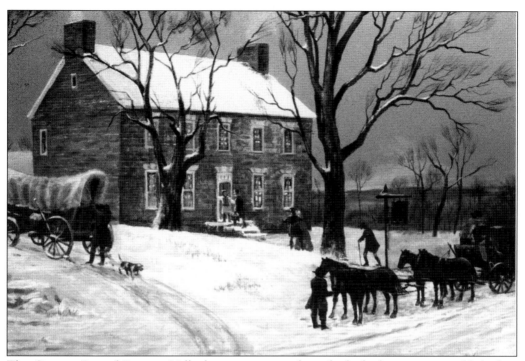

The Century Inn of Scenery Hill, shown as it must have looked when it was established in 1784 and called Hills Tavern, is depicted in this painting by artist Ray Forquer. At that time, the town was called Hillsborough after founder Stephen Hill, who also opened the first line of passenger coaches on the National Road in 1818. It is the oldest continuously run inn on the National Road in Pennsylvania.

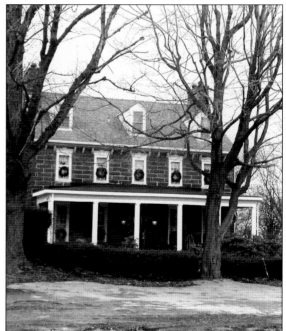

Once the pike arrived, Hills Tavern (seen as it looks today) hosted many travelers, including General LaFayette on his famous voyage of May 1825 and Andrew Jackson, who stayed here on the way to his inauguration as president of the United States. (Author.)

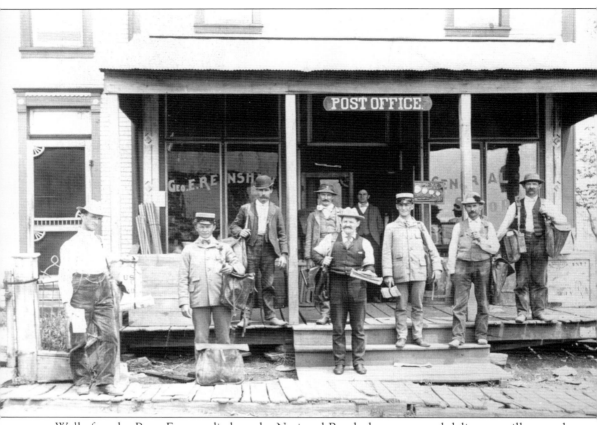

Well after the Pony Express died on the National Road, there was rural delivery, as illustrated by this post office and mailmen in Scenery Hill. That was done by a bevy of postmen, who like the riders before them delivered the mail either on horseback or bicycle and eventually by automobile. (Washington.)

Just west of Scenery Hill before the modern-day Westerwald Pottery is a large brick building that was once the Charley Miller Tavern. This tavern operated during the heyday of the road. During the automobile era, when it was called the Eastern Pines Tourist Home, it was still a favorite spot for locals to come to dine and dance. The building is now painted white, and a flagpole stands in the front yard.

Dead Man's Hollow, between Odell and Glyde, was given its name because a dead man was found there. This is how it appeared c. 1910. It is followed by Egg Nog Hill, named by a team of workers and engineers who built the road. Before tackling the complicated hills of the terrain and finalizing the route of the road up the hill, they stopped for the night. Then they enjoyed too much spiked egg nog and felt it the next day. (Bruce.)

Just before Glyde is one of the magnificent farms and barns on the road. Prior to alterations, the barn was south of the road, but when the Route 40 interchange came, the road passed to the north of the barn. At one time, the surrounding countryside was dotted with oil derricks. (Old Pike.)

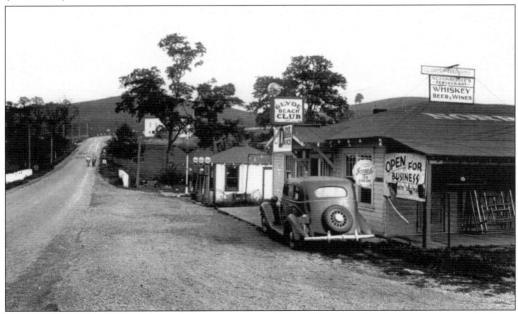

The Glyde Beach Club was a popular spot in the 1930s. This view looking east shows the barn of the previous picture too. In later years, a motel stood here, and the site is now occupied by apartments. Glyde is also known as Davidson. (Old Pike.)

In stagecoach and wagon days, Glyde was known for the long stretch of straightaway in an otherwise curvy National Road. Freighters took full advantage of the terrain and whipped their teams into a gallop. Again looking east, we see a farm, the Glyde Beach Club, and the old barn along the long stretch. (Old Pike.)

As the road crested the hill beyond Strabane, it came to one of the busiest corners in Pennsylvania. The Thomas Hastings Wagon Stand was a stagecoach stop (on the left just outside the picture). Robert Doak became proprietor *c.* 1863, and the area became known as Doakville. A few yards west (the north side) was the Upland House, a large frame building. Searight maintains the Upland was for aristocrats, while Hastings was for pikers. (Old Pike.)

The Kopper Kettle Tavern, still open, was a favorite spot for the automobile-era travelers on the National Road. (Old Pike.)

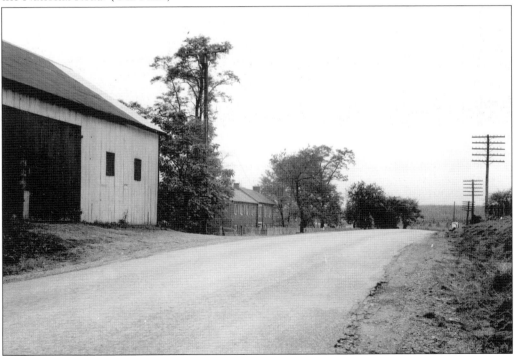

The Moses Little wagon stand, now an antique shop, claims its place in road history too. On July 3, 1922, Pres. Warren G. Harding was returning to his home in Marion, Ohio, along the National Road. Harding's caravan, which included 42 people in 12 cars escorted by secret service men and state police on motorcycles, stopped here. The old barn is now gone. (Old Pike.)

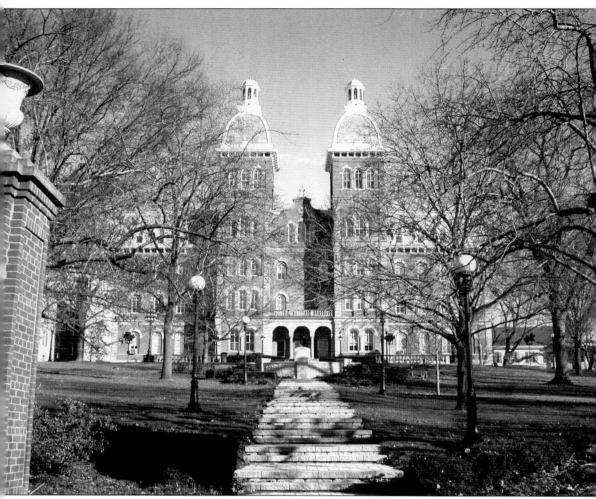

For nearly two centuries, the community of Washington in the county by the same name has been dominated by the twin towers of Old Main, located on the campus of Washington and Jefferson College. Route 40 and the National Road enter the community to the south of the campus on Maiden Street. The town was known as Catfish Camp by American Indians, as the surrounding area was the hunting ground of Tingoocqua (Catfish), a Delaware Indian. In fact, the entire area of Washington and Greene Counties was part of the Iroquois hunting grounds. (Author.)

This painting by Ray Forquer shows the men of Brady Company going to war in 1862. The LeMoyne House (49 East Maiden Street) was the home of Dr. John LeMoyne (father) and Dr. Francis LeMoyne (son). The home was a station on the Underground Railroad. Francis LeMoyne was so committed to the end of slavery that he ran for vice president three times on the Abolitionist ticket of the Liberty Party. He also build the first crematory in the United States on Gallow's Hill nearby. The house, built in 1812, is Greek Revival in design and is currently the headquarters of the Washington County Historical Society.

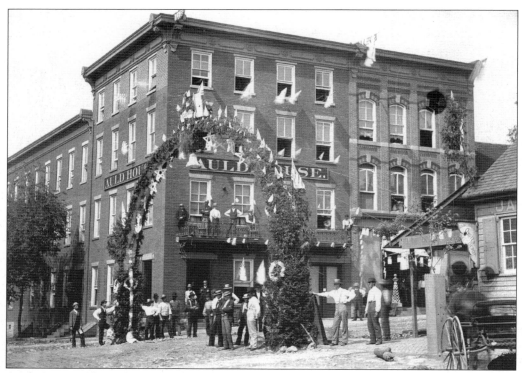

At the corner where the National Road turned onto Main Street stood the Ault House, one of many taverns that littered Washington and the last to remain open. (Washington.)

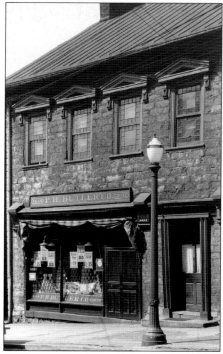

The Bradford House was the home of David Bradford, an affluent attorney and friend of George Washington. He was also one of the leaders of the Whiskey Rebellion. He was forced to flee Washington, never to return. The house was the first stone house in Washington. (Washington.)

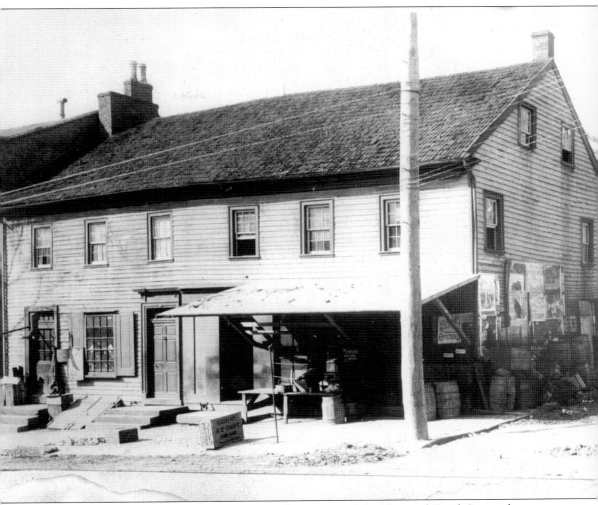

The Globe Inn opened in 1798, well before the coming of the National Road. It was the most popular tavern in Washington. Chief Blackhawk and five chiefs were prisoners of the United States here from April 16 to 18, 1833, when their stagecoach overturned after the Blackhawk Wars. Made of wood, the inn was torn down in 1891. (Washington.)

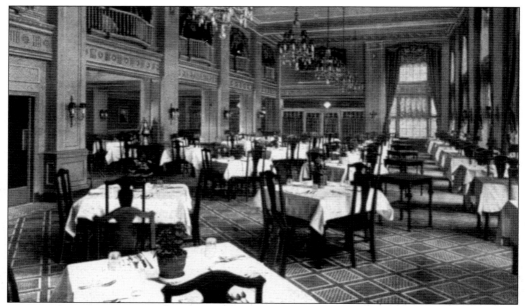

Among the treasures of the automobile-era George Washington Hotel are the dining room murals that depict life on the National Road, painted in 1935 by Washington County's Malcolm Parcell. Parcell lived at Moon Lorn, a woodland cottage now owned by the Malcolm Parcell Foundation, which has turned it into an artist colony.

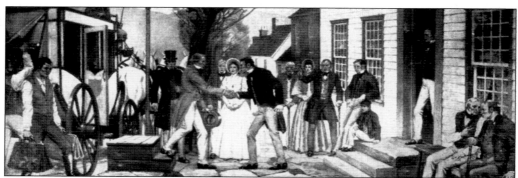

LaFayette's visit to Washington on May 25, 1825, is captured in this view. (Evans-Parcell.)

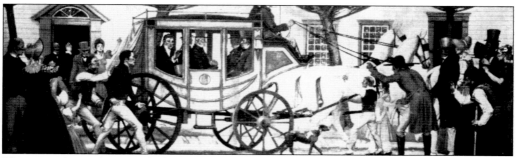

This view shows the arrival of Henry Clay on May 16, 1844. (Evans-Parcell.)

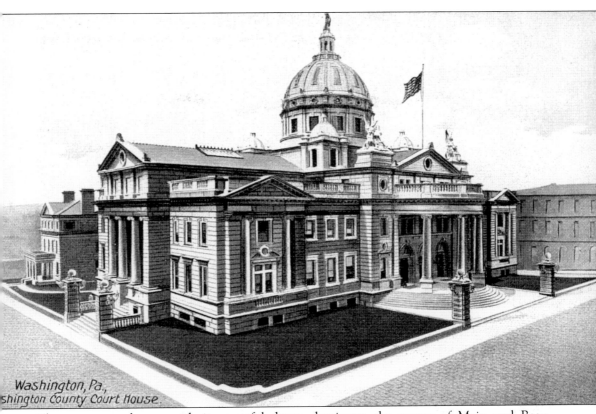

Washington, Pa.,
shington County Court House.

The stone courthouse, with its graceful dome, dominates the corner of Main and Beau Streets. Designed by Pittsburgh architect F.J. Osterling and erected in 1900, it is a Beaux-Arts masterpiece. George Washington stands atop the dome, while inside, the main hall is decorated with marble.

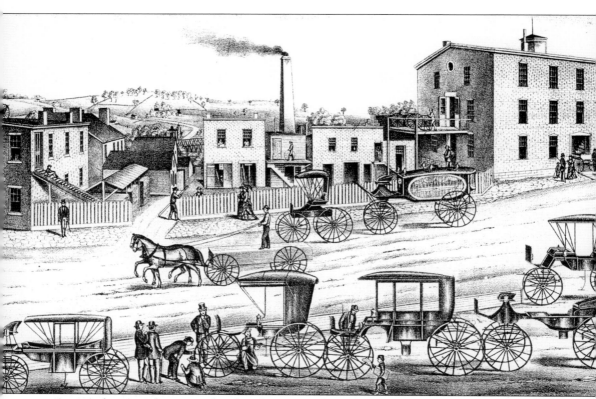

Among the many factories related to the National Road in Washington was the George Brown factory (which invented the "stogie," a small cigar used by freighters and stagecoach drivers) and the Hayes Carriage and Wagon Factory. The latter, its fine work seen here, was established *c*. 1841 and built wagons and square-bodied stagecoaches for the road.

A little over a mile and a half from Route 70, just after Sugar Hill, is a good example of a coal patch. Created *c.* 1917, the company store is on the flatland, and the patch houses line the south side of the hill on the original National Road. The mine was across the road.

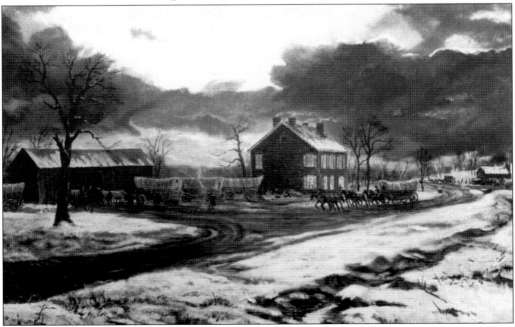

Coulson's Tavern was one of the wildest drover's taverns in Pennsylvania, perhaps on the entire National Road. At night, the drinking and carousing could spill onto the road. This winter scene by artist Ray Forquer shows the tavern at twilight as it might have appeared in the 1830s. Today, the brick tavern and old barn have been restored by the homeowners. (Forquer.)

At the top of Mounts Hill (the north side) is Wilson Tavern and wagon stand. In 1892, Thomas Searight got a letter that read, "Thirty six-horse teams [were] on the wagon yard, one hundred Kentucky mules in an adjacent lot, one thousand hogs in other enclosures, and as many fat cattle from Illinois in adjoining fields. The music made by this large number of hogs, in eating corn on a frosty night, I will never forget." Such was life on the National Road. (Author.)

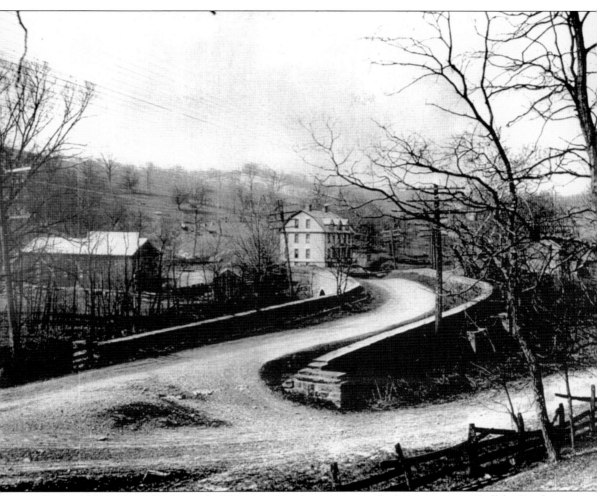

Built in 1818, the S-Bridge, a double-arched bridge constructed of stone, crosses Buffalo Creek. It got its name from its unique construction. Why an S? It is uncertain, but the best explanation is that a straight bridge needed support in the water, but an S-Bridge, which crossed the water at a right angle, did not. The bridge is one of two remaining stone bridges on the National Road in Pennsylvania. The other is at Coon Island beyond Claysville. (Lacock-Washington.)

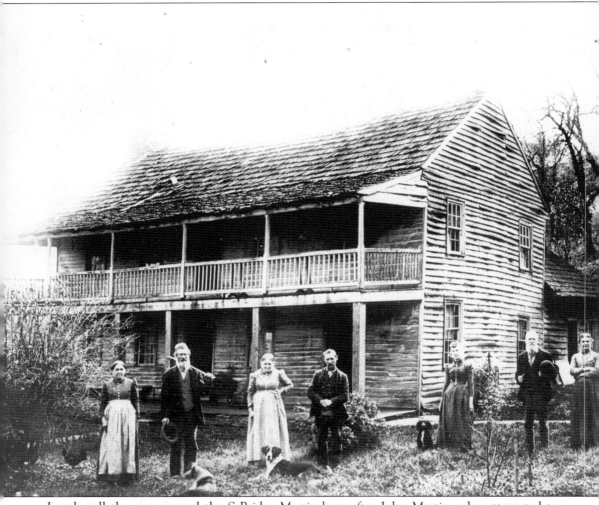

Locals call the area around the S-Bridge Martinsburg after John Martin, who attempted to found a town here. According to Searight, there were two taverns. The eastern tavern was Bedillions (the north side), and the western one was the S-Bridge Tavern, seen in this c. 1890s view, which includes the tavern owners. (Washington.)

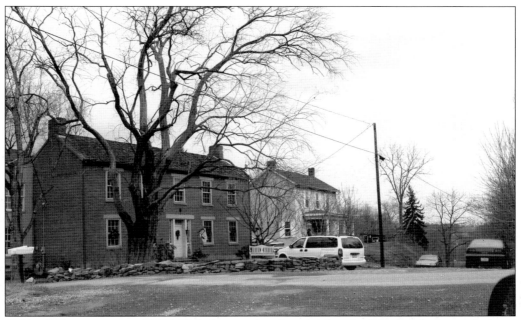

Caldwell Tavern sits atop Kelly's Hill, four-tenths of a mile after the S-Bridge. Its entrance (seen here) faces the National Road, and its back faces Route 40. The site has had a rich history, and many structures have been erected here. (Author.)

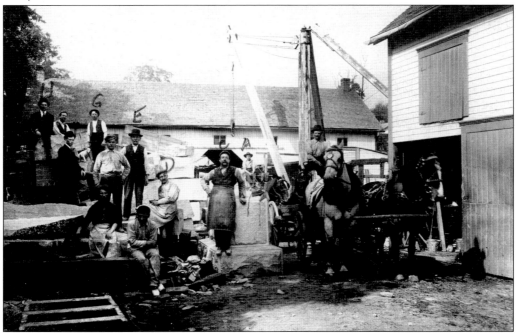

White's Monuments was one of dozens of small businesses in Claysville. It serviced citizens in the small conservative town for over 100 years. Many of the tombstones in the cemetery (next page, top, far right) come from the White shops. This photograph was taken in the early 20th century. (Pap's.)

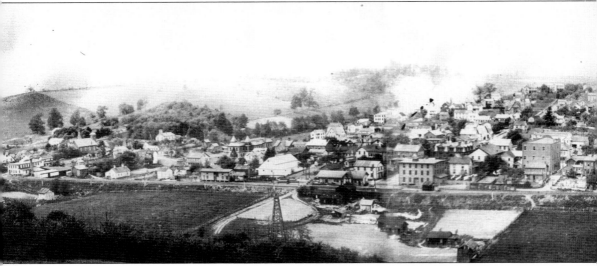

Claysville, founded in 1817 as a pike town, was named after statesman Henry Clay, a frequent traveler on the road. In this panorama, taken from a nearby hillside, the National Road enters

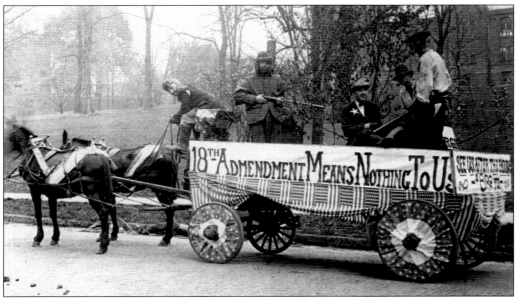

The people of the road, then and now, have a history of rebellion. The Whiskey Rebellion was only one of the battles fought here. When Prohibition was declared, people wanted nothing to do with it. Here is a sampling. (Old Pike.)

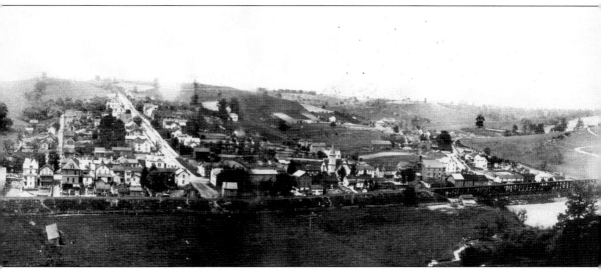

the community on the far right (east) and forms the main street. The photograph dates from before 1922, when a whole city block burned to the ground and was rebuilt. (Pap's.)

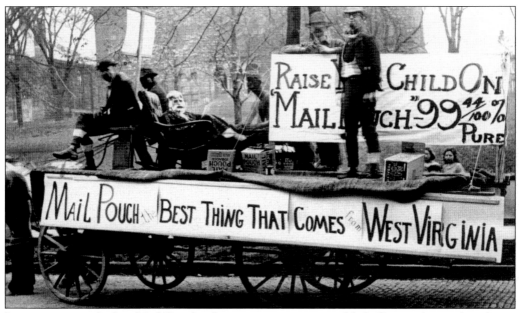

It was not enough that Mail Pouch advertisements were sprinkled all over the road on barns and signs; it was advertised even on floats. (Old Pike.)

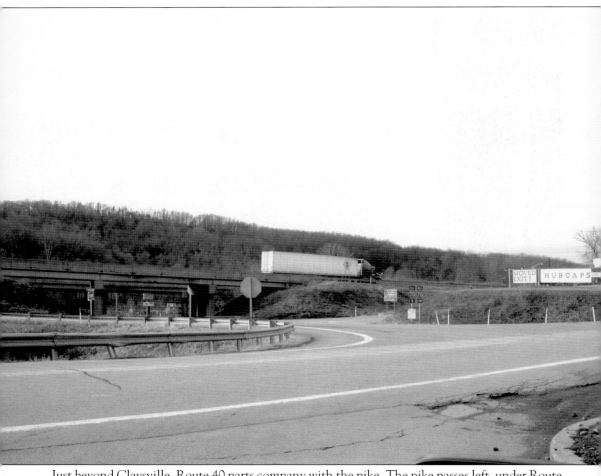

Just beyond Claysville, Route 40 parts company with the pike. The pike passes left, under Route 70. While Route 40 continues west, the three roads run almost parallel—Routes 40 and 70 in the lowlands, and the pike riding the ridge through this beautiful farm country, which looks much as it did when it was first settled.

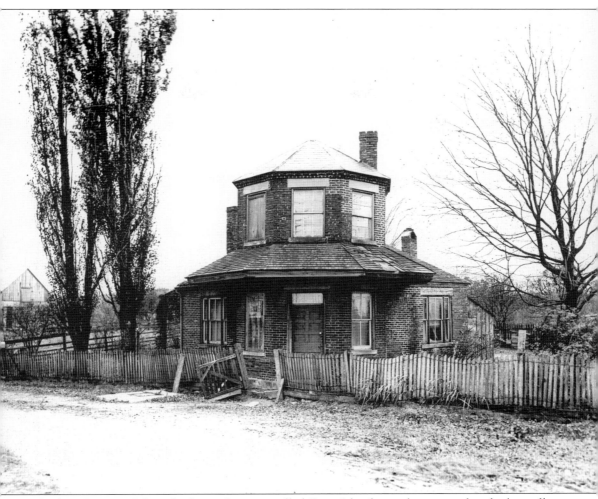

As the pike topped the ridge beyond an area called Coon Island, travelers stopped at the last toll house in Pennsylvania. The hill was a tough one for horses because of the many curves and the steep grade. The toll house was probably a very welcome site. Gone now, it was still standing in 1955. Abandoned by the state, it fell to ruin, became a speakeasy, and was offered free to groups willing to save it. No one did. A farmer used it to store hay, and now it is gone. Several of the farms in the area have added "toll house" to their names. (Lacock-Washington.)

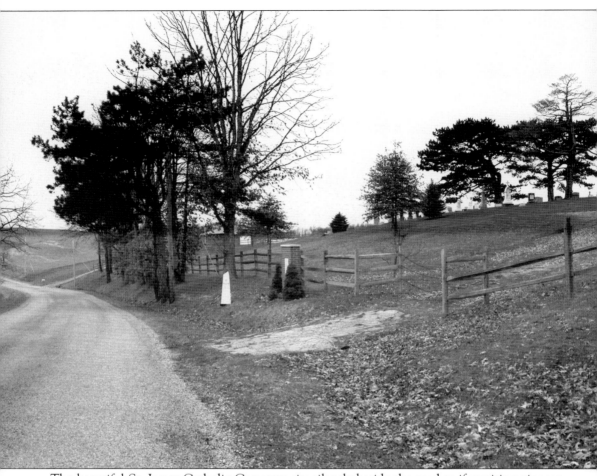

The beautiful St. James Catholic Cemetery sits silently beside the road as if awaiting pioneer visitors. The first Catholic mass in Washington County was celebrated in a cabin here in 1811. The St. James Chapel, erected here in 1821, was the first Catholic church in the county. It was built not only by contributions by parishioners but with funds donated by workmen on the National Road. The church is gone, but the cemetery remains and the road looks much as must have been then, down to the gravelly surface. (Author.)

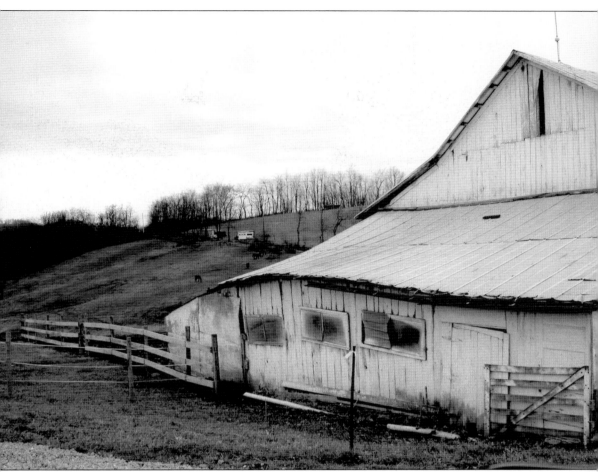

Two taverns existed in this area of the National Road. Both were owned by John Valentine. At the top of the hill was Rogers Tavern, a frame wagon stand, and the second tavern at the bottom of the hill was for stage passengers. Valentine operated a still on this property to produce whiskey for all his customers. This barn is on the valley property. (Author.)

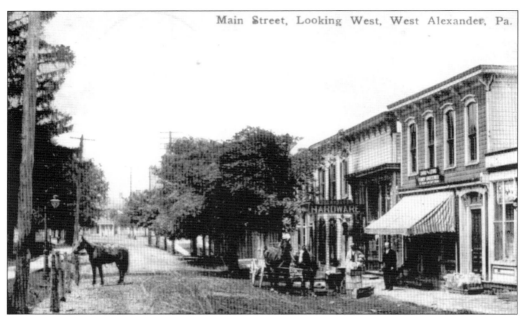

Just when it appears you are driving into pure wilderness, the village of West Alexander emerges. West Alexander was a town of craftsmen: cabinet makers, shoemakers, potters, weavers, carriage makers, cigar makers, and hat makers. When the National Road was completed to West Alexander in 1820, some 25 stagecoaches stopped in the town every day.

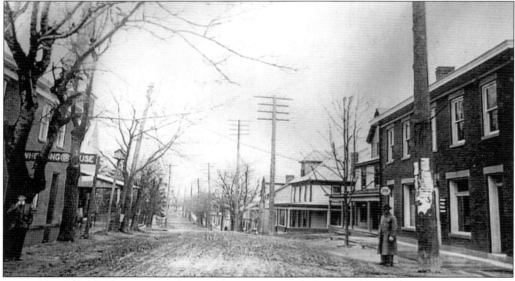

West Alexander had one more claim to fame. So near to the state line, it became known as the marrying town, which explains why it is sometimes called Gretna Green after the same type of town in England. At that time, Pennsylvania did not have marriage license laws, whereas nearby Ohio and West Virginia did. Therefore couples wishing to avoid the laws came to Pennsylvania. The first stop in Pennsylvania was West Alexander. More than 5,000 marriages were performed during the 1825–1885 period. The state line also played a role in creating an Underground Railroad system in West Alexander. (Mansmann.)

Five

THE NATIONAL ROAD AS A LIVING HISTORICAL BYWAY

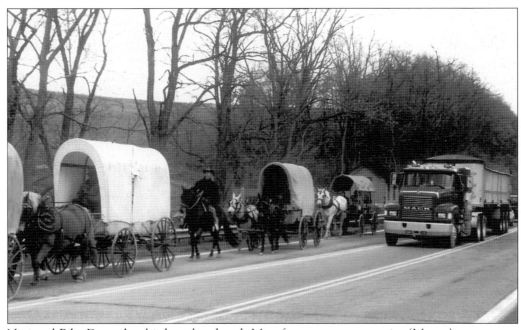

National Pike Days, the third weekend each May, features a wagon train. (Moon.)

The Mount Washington Tavern is just one of the many buildings along the National Road in

Pennsylvania that has been restored. (Author.)

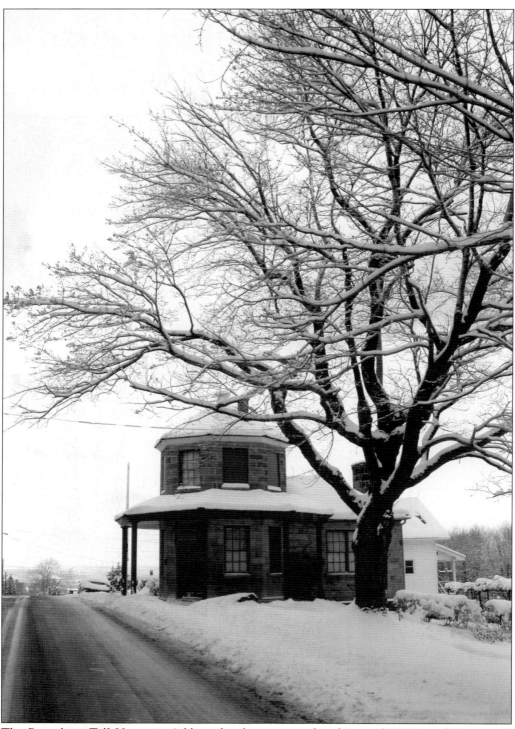

The Petersburg Toll House in Addison has been restored and is on the National Register of Historic Places. (Author.)

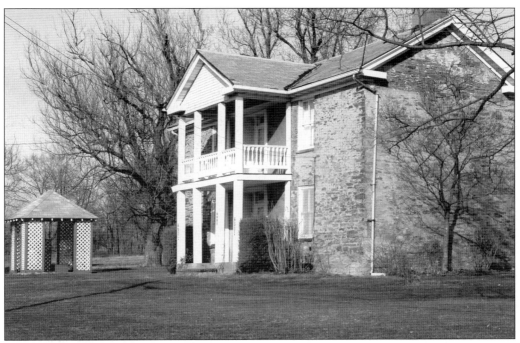

All along the route of the National Road in Pennsylvania are historic taverns that are now private residences. This one was once called the Skeen-Wallace tavern. (Author.)

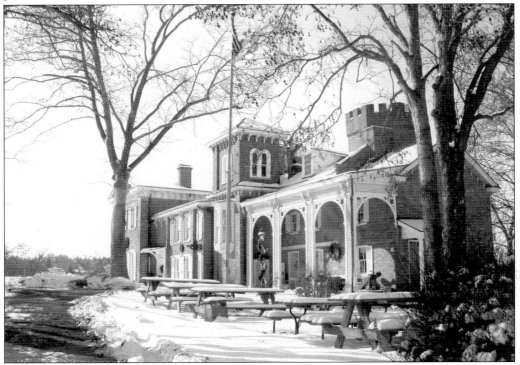

The Nemacolin Castle still sits as sentinel over the Monongahela River in Brownsville. (Author.)

The wagon train pulls onto the road after a rest to continue its journey along "the old pike." (Moon.)